MARY RANDLETT LANDSCAPES

MARY RANDLETT

Contributions by Barry Herem, Jo Ann Ridley, and Joyce Thompson

UNIVERSITY OF WASHINGTON PRESS SEATTLE & LONDON

LANDSCAPES

Introduction by Ted D'Arms

With an essay and poems by Denise Levertov

IN ASSOCIATION WITH TACOMA ART MUSEUM

This book was supported in part by the
DONALD R. ELLEGOOD ENDOWMENT

University of Washington Press
P.O. Box 50096, Seattle, WA 98145
www.washington.edu/uwpress

Tacoma Art Museum
1701 Pacific Avenue, Tacoma, WA 98402
www.TacomaArtMuseum.org

The poems by Denise Levertov on pages 35–47 are
from *The Sands of the Well,* © 1994, 1995, 1996 by Denise
Levertov, and are reprinted here by permission of New
Directions Publishing Corporation.

Library of Congress Cataloging-in-Publication Data
Randlett, Mary.
Mary Randlett: landscapes / Introduction by Ted D'Arms
With an essay and poems by Denise Levertov ; contri-
butions by Barry Herem, Jo Ann Ridley, and Joyce
Thompson.— 1st ed.
p. cm.
Includes bibliographical references.
ISBN-13: 978-0-295-98720-0 (hardback : alk. paper)
ISBN-10: 0-295-98720-0 (hardback : alk. paper)
1. Landscape photography. 2. Randlett, Mary. I. D'Arms,
Ted. II. Levertov, Denise, 1923-1997. III. Tacoma Art
Museum. IV. Title.
TR660.5.R36 2007
779'.36—dc22 2007007351

This book is dedicated to

my mother, the curator and collector Elizabeth Bayley Willis

Hans L. Jorgensen, photographer and mentor

Donald Ellegood, emeritus director, University of Washington Press

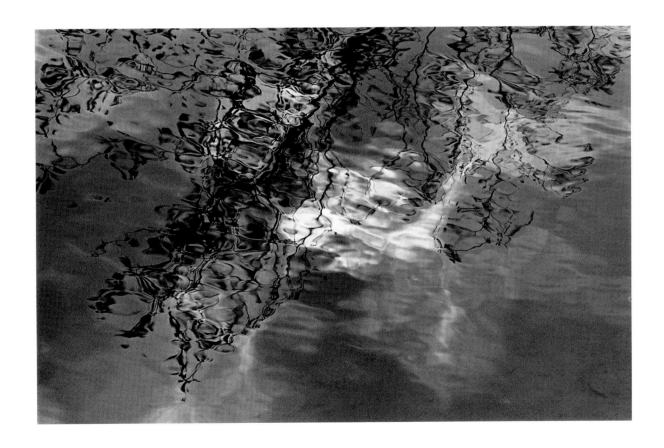

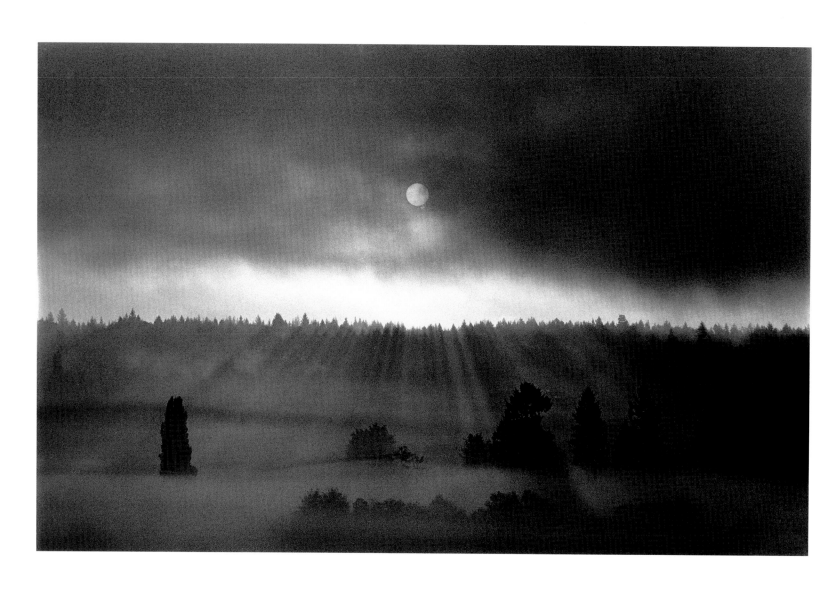

VI / MIST RISING, SEPTEMBER 1989

Chinese artists understand better than
any others the value of empty spaces,
and in a certain sense what they left
out was more important than what
they put in. . . . they lifted just a corner
of the veil to excite people to find out
for themselves what lay beyond.
 —Alan Watts, The Spirit of Zen

To see the world in a grain of sand
And a heaven in a wildflower
Hold infinity in the palm of your hand
And eternity in an hour.
 —William Blake

Those who are willing to be vulnerable
move among mysteries.
 —Theodore Roethke

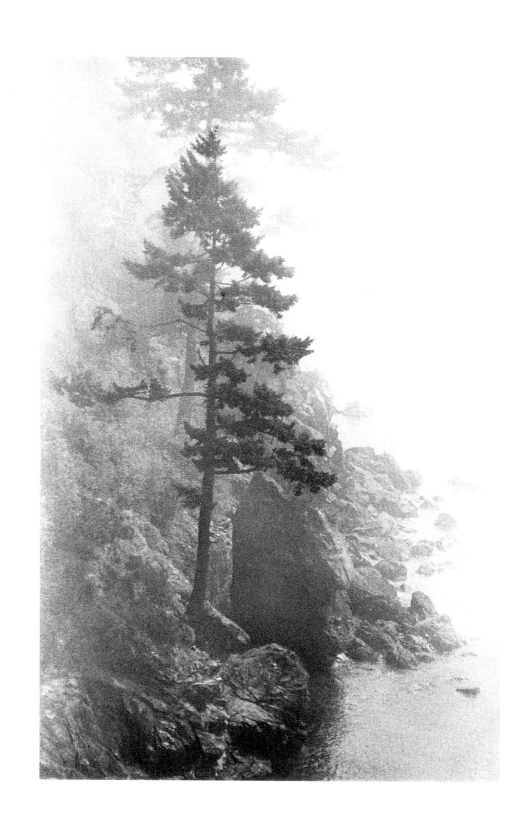

VIII / DECEPTION PASS 1, JULY 1972

CONTENTS

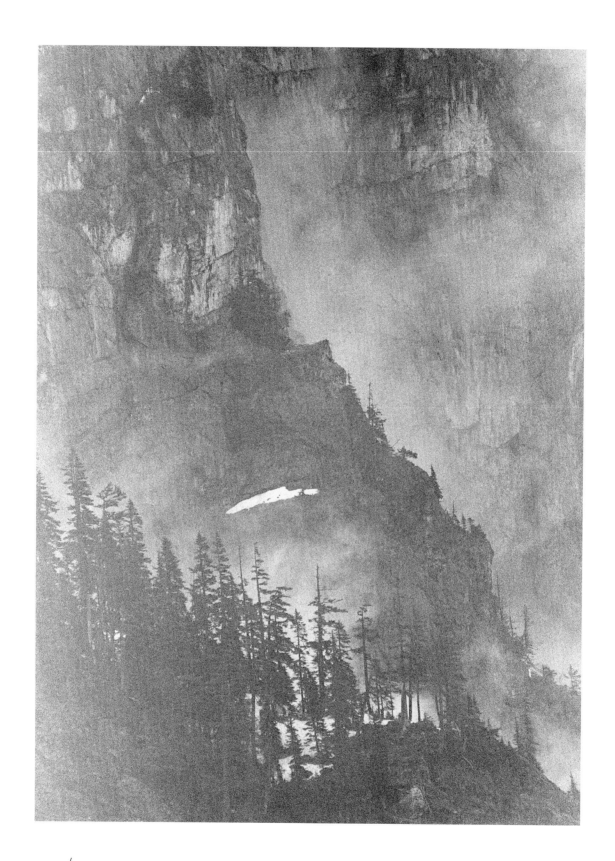

X / ALPENTAL, JUNE 1970

MARY RANDLETT LANDSCAPES

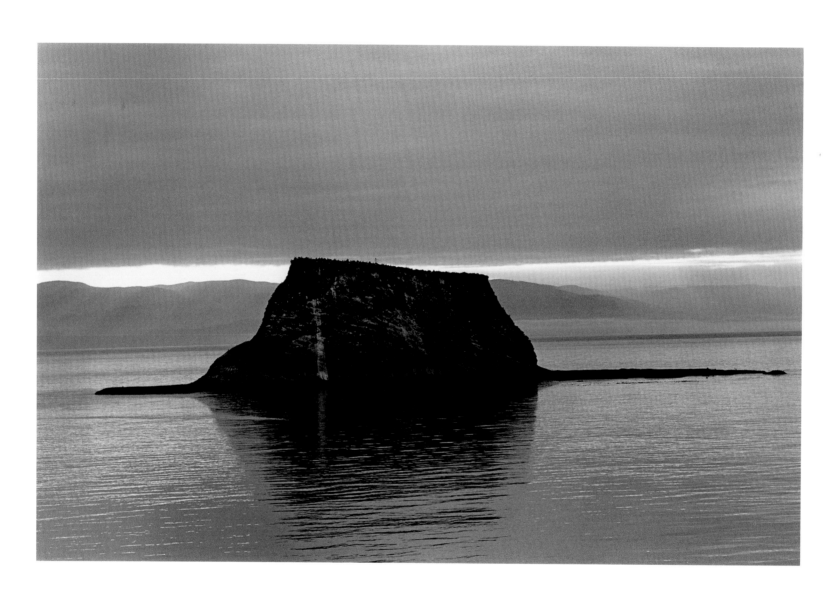

2 / SAIL ROCK, JUNE 1986

Introduction: Lifting the Veil

TED D'ARMS

THE IDEA FOR THIS BOOK WAS CONCEIVED IN THE EARLY 1980S. I was serving as a photographic judge at an annual Northwest summer fair and awarded first prize to a strange and beautiful, sumptuously printed photograph of a monolithic flat-top rock, a sentinel over a vast watery plain. The photograph was haunting—a myriad of grays and blacks on an overcast day. Mary Randlett called me several days later to say that this was the first First Prize she had ever won. I was floored.

We met soon after that, and I was added to the long list of recipients of her annual Christmas cards: images from nature that she had taken during the previous year. These luminous, hand-printed photographs captured the beauty of the Northwest, as well as its mysteriousness. When I asked to see cards from previous years, she generously gave me access to her studio. As I went through years and years of her nature work, it became clear that she had an approach to photographing that captured the very essence of the region's light, forms, and rhythms, and it struck me that they would make a lovely publication. Mary and I thus began the long process of distilling forty years of her nature photography to fit between the boards of a book.

Mary had been an ardent admirer of Denise Levertov's poetry for many years. When Denise moved to Seattle in 1989, they became regular visitors and correspondents, and the admiration became mutual. On seeing some of Mary's photographs, Denise was inspired to write poems; seven are included here, with her permission. Mary offers this book as a tribute to her friend.

American novelist Henry James, when asked what kind of man he would like to be, responded, "I would like to be the kind of man on whom nothing is lost." In the proper, educated, encyclopedic, sophisticated world of Henry James, to be aware of everything hinted at hair-splitting differences,

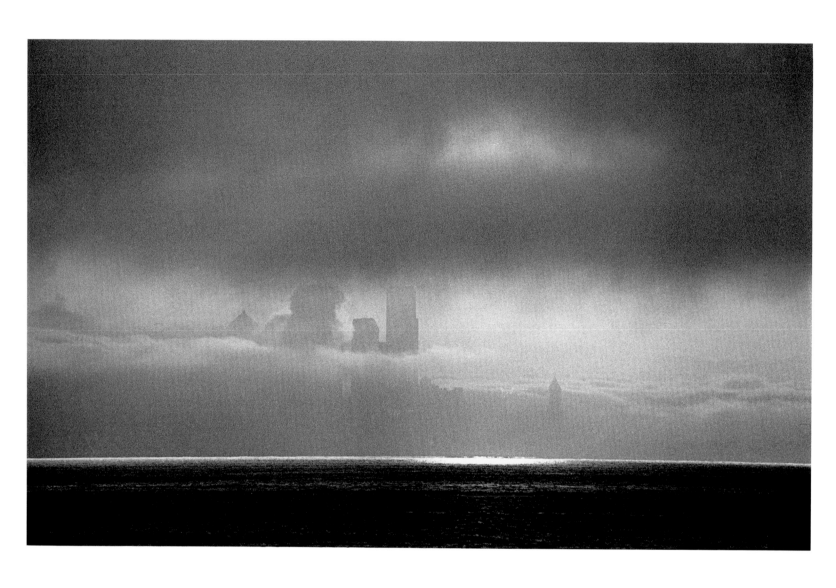

4 / EMERGING CITY, SEATTLE, MARCH 1993

infinitesimal shadings of color, or tiny degrees of moral consciousness. When considering today the kind of person "on whom nothing is lost," I am struck by something far more vigorous: a person who can entertain simultaneous points of view. A person who can identify big concepts and small details. A person with tremendous generosity of spirit and a willingness to let people and places exist for whom and what they are. A person with the ability not to assert herself conceptually or graphically onto the physical world before quietly and attentively observing all the variants, old and new, and how they intermingle and mesh. Mary Randlett is the kind of person on whom very little is lost.

Mary has practiced her craft for well over fifty years in the same part of the country—the Pacific Northwest. Exploring and observing the outdoors has always been more important to her than indoor pursuits. If her photographs can be seen as the wondrous ornaments at the tips of her above-ground branches, her root system is large and deep. She works with local artists, regional preservationists, writers, poets, environmental architects, historians, professors, anthropologists, and Northwest carvers and sculptors. It is the application of this storehouse of acquired information which she brings to her photography. She is as attuned to nature's finite changes as is the farmer sitting around waiting to taste the density of the season's first rain squall. Her degrees of watching, waiting, testing, sifting, poking, prying, turning things over and over have intuitively led her to some very distinguished photographic moments. When she observes a scene that engages her, not only does she ask herself what the best angle might be or what exposure best captures the tones she is seeing, she contemplates different times in the day, month, season, and year when the light, foliage, reflection, or degree of moisture in the air might better serve a more complete, well-defined photograph.

Mary Randlett came of age mid-century. World War II was over. The United States had become the undisputed leader of the free world. Peace had descended again and with it security and an unquestioned faith in family, children, education, the church, and the state. The world was stable. The country was safe. This reassuring framework allowed Mary to explore the Pacific Northwest freely. It was reasonable for her to assume that what she saw and what she perceived were pristine; the great outdoors was still pure. The shorelines, beaches, and forests were sparsely populated except by indigenous inhabitants. Directly observing the life cycles of flowers, the changing tides, the passing of one season to the next, and the daily activities of bird and fin were the starting points for her vision. The more she photographed, the more her simplicity and tenderness toward the subject matter emerged. The ever-changing tonal increments so prevalent in the Northwest began to appear in kaleidoscopic variations in her photographs. As her affection for these quali-

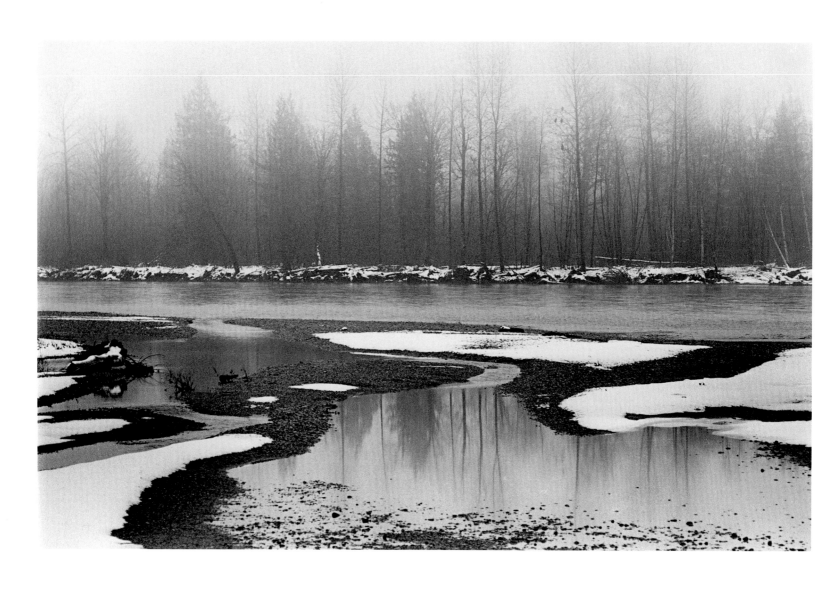

6 / ROCKPORT, SKAGIT RIVER, JANUARY 1982

ties grew, the closer she came to capturing the subtleties within a place. She attuned her eye and her feelings to a presence deeper than the mere recording of images and facts—to a distillation of the effects of time and a feel for ongoing natural cycles year after year. Mist on the sea coast will always rise from the ocean's surface up adjoining hillsides. But to capture and suggest the time-lessness of this ephemeral activity—the mist is rising now—rose yesterday—and will rise again tomorrow whether man is present or not—is a much more subtle task. Even though mist seems to form out of nothingness and evaporate back into nothingness, it is the mist that is constant, not humans with their drive-by relationship to nature. The ability to penetrate the reality of place gives Mary's photographs a strong presence of the eternal. Perhaps it was the nature of the times, the make-up of the artist, the deeply magical qualities of the Northwest, or a combination of all these that has allowed her to produce a body of work that deeply resonates with the complex and lasting beauty of the landscape.

The first Randlett photograph I ever saw was a small print of a black rain cloud over a vast area of open water (taken in 1971). No boat, no shoreline, no signs of man are evident. Rain pours out of the cloud onto the sun-dappled expanse of water. The water's surface is dotted with the soft shadows of loosely formed clouds from overhead, but there is no shadow under the huge black rain cloud. The black wash of descending rain creates no visible impression on the water below. Rain, light, sun, dark, shadow. Aside from these peculiarities, the photograph gives off the feeling of being witness to an incredible natural phenomenon, a unique fleeting moment in the natural world that the artist just happened upon. Mary's instantaneous response captures the surprising qualities of the moment, both for herself and for us. The major themes of her work are all present here; the pristine natural world, an amazing event, a distinguished moment in time, the entire scene bathed in unique Northwest light.

This living presence is again brought home in a photograph of a stony riverbed covered with patches of blank snow. The day is overcast. There is a wet, flat, shadowless light over the whole scene. One can feel the coldness in the rocks and lifeless water. The ragged line of bare trees in the background is shrouded in a dirty mist. Even the compositional and graphic elements of the pho-tograph are loose, splotchy, unreassuring. It is a scene as cold and undistinguished as any we have ever tried to forget. We are chilled to the bone. This is an ordinary winter day for Northwest sports-men and it is as familiar as an old sopping-wet wool glove. The photographer has stripped away all of the normal means of seducing a viewer into "liking" the place. It is not seductive but it is utterly convincing. Its believability is unquestionable. The viewer becomes hypnotized by the barely definable elements that contribute to such an accurate depiction of place.

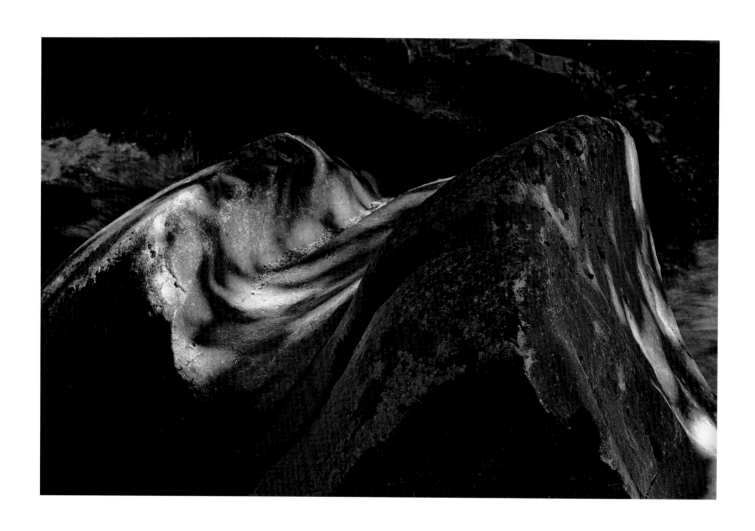

8 / RIVER ROCK IN SHADOWED SUNLIGHT, JULY 1986

The Vision Changes

Very slowly over the decades, the golden paradigm that defined Mary's world and informed her vision shifted. The all-encompassing complex of cultural values that gave meaning and motivation to life in the fifties had turned into something darker, more cynical. It was no longer the church, the state, the nuclear family, service to others, responsibility toward the community, and certainly not a deep commitment to the companies that employed us which held our world together. They had all been seriously eroded. They continued to assert themselves where they could, but they no longer provided the reliable structure on which we depended in times of crisis and doubt. Crisis and doubt had become widespread. While new coalescing institutions had yet to fully crystallize, the short-term goals of acquisition, money, celebrity, personal power, and advertising had been brokered as the "new way." These were primarily urban preoccupations, dealt with by city people to obtain city solutions: specifically, profit. These urban values were being forced into shopping malls, multiplex cinemas, sports stadia, hundreds of channels of television, and the ubiquitous all-inclusive worldwide Web. Most people have come to lead the bulk of their lives through these outlets; screens (television), screens (computers), screens (film), screens (video games), screens (during sporting events). Screens for groceries, banking, investing, travel, surgery, sex, taxes . . .

This is not the place to question the accomplishments of screen reality; they are obviously many and important. But it is the place to note that screen reality is a stand-in for something that is happening somewhere else—for actual experience. The purpose of simulated reality is to evoke—to re-create—experience for the viewer. Mary Randlett is not out to make angels dance on the head of a digital pin. Her photographs are straightforward, unmanipulated. She depends on what she finds, not what she can concoct. She experiences the natural world directly, with its marvelous spaces and surfaces, its endless miracles of light and shadow, the sparkle of waves or the fog in the trees. Her photographs take us away from simulation and bring us back to the rich, unpredictable, and astounding revelations of actual experience—the real world.

Mary Randlett's approach to nature photography has always excluded irony. She doesn't distance herself either from the subject matter or from the viewer. She has photographed what moves her and has attempted to convey something more out of what she witnesses than the single facts in front of her camera. She has photographed what she understands of the truths behind the facts of the natural world. But when a heartfelt response to the world came to seem a little corny, when everything became a little "iffy," it was time for her to adjust her vision. Perhaps she wasn't consciously reacting to the seismic cultural shifts happening around her, but her work changed dra-

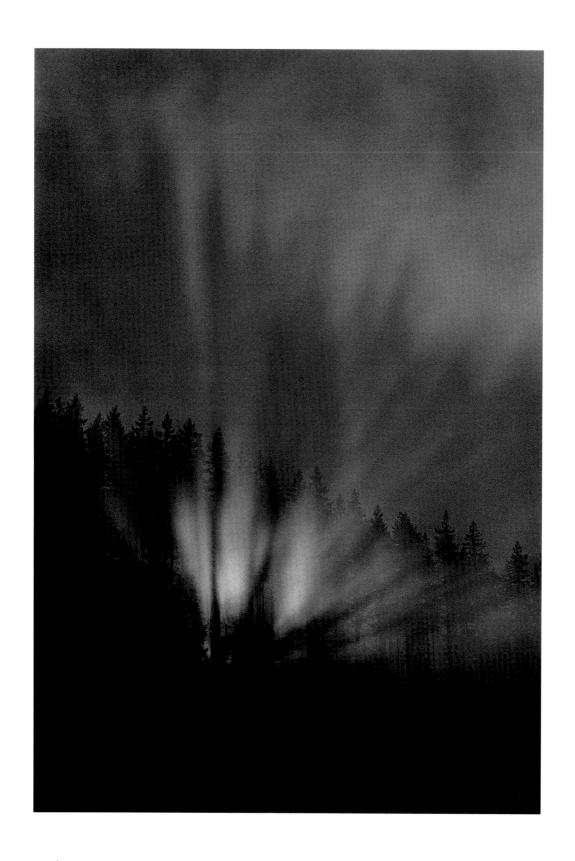

10 / COASTAL HILLS SUNRISE, DECEMBER 1987

matically. Through her daily contact with nature (she rode the ferry across Puget Sound often for twenty years) and her constant evaluation (analysis is too clinical a word) of the changing light and natural forms she encountered, she immersed herself more deeply in the fundamental truths of nature; the essence of light and form. As her work became freer of sentiment, it gained in clarity and richness. Her concentration and intensity brought a burnished quality to the work only hinted at in her previous images. Her photography became simpler and at the same time more mysterious.

In July of 1986, walking along a stream bed high in the Cascades, Mary was startled by striated sunlight conforming to similar undulations in a glacial rock. She photographed it. She wasn't sure if she was taking a photograph of the rock or the sunlight playing on it. She treated both equally. The more she studied the finished photograph, the more she was drawn to the light—the way the light appeared as a subject—light as content—light in and for itself, not as an illuminator of subject matter.

This reversal from identifying with objects in front of her camera to experiencing the light illuminating those objects was a revelation, a paradigm shift, an explosive doubling of her understanding of photography. She suddenly felt she had twice as much to photograph. She perceived things in a new light—literally. And with this perceptual wrenching, her understanding of the Northwest changed as well. She could now see how light defined the world.

The dull flat directionless light of overcast days
The soft hazy sunlight hovering mid-air, irradiating everything and casting soft cottony edges
Stacked gray clouds dumping their pewter light down on open water
Bolts of sunlight splitting the cloud-choked skies
The distant bright shimmer where cloud and mountain ridges are separated by only the most
* microscopic tint of gray*
The lightless light left after hours of falling rain have sucked the vitality out of it
The thick murky light that reluctantly oozes into dark corners
The crisp clean light after days of showers that make the plants and trees gasp for air
The broken sunlight in high mountain snowfields where snow, mountain, light, and shadow
* seem interchangeable*

Many photographers assume that without sunlight there can be no photography. Mary came to realize that the ever-modulating light of the Northwest was much more interesting and revealing of place when it wasn't flooded by "contrasty," direct sunlight.

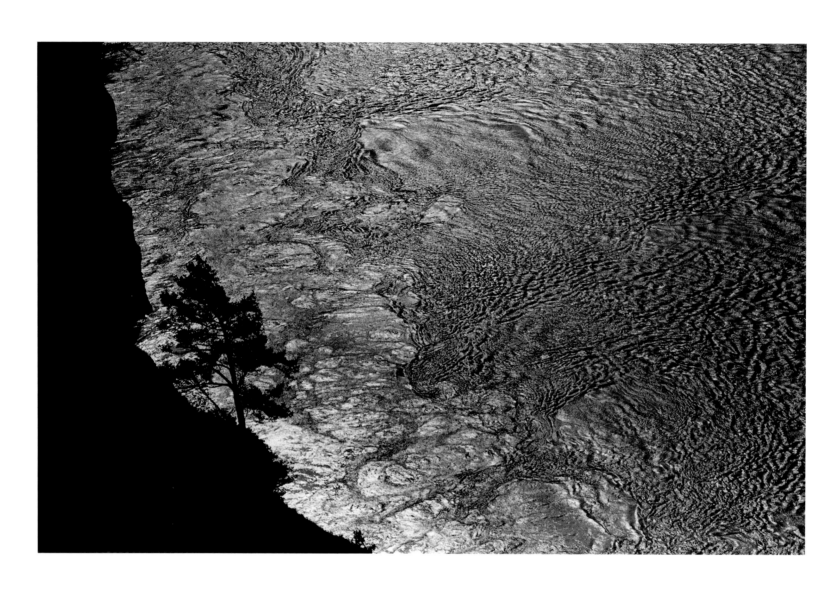

12 / DECEPTION PASS 2, JULY 1989

A stunning example of light-becoming-the-subject is a 1989 photograph of a black ridge of fir trees against an almost black sky. Blazing upward from behind the ridge are white shafts of light. Light normally comes down from above. Here the well-defined rays shoot dramatically skyward above the trees. It is difficult to imagine a better depiction of the triumph of light over darkness. The photograph is dark and mysterious, but it is also affirmative and uplifting.

Another 1989 photograph illustrates a more subtle application of light. The silhouette of a lone pine sticks up out of a completely black ascending form on the left side of the photograph. This is the framing device for the real subject of the picture; the shimmering surface of coastal water slipping away from the shore off into the distance. This complex and jewel-like surface appears to be simultaneously a close-up and a distant shot. The sun backlights the whole scene, etching the smallest ripple and wavelet onto the roiling surface. The different wave forms are spun out of a seemingly infinite variety of changing wind and current patterns. Light darts and zigzags through the photo as if it were an electrical pulse zooming through the world's largest intricate computer chip. It is a dazzling photograph.

Here is Mary on light, wind, and rain:

I lived near the water all my life . . . lived in that tossed light that came invisibly through the trees at sunrise and carried the dancing light of the rising dawn, sunlight of dancing waters light, to the walls—that light of shadows moving invisibly through our woods but not visible—just somewhere till the light fell upon a surface—in the forms it had picked up in its silent unseen travel through endless space—like the wind an invisible thing—an invisible force only felt but not seen till it blows through things that can be moved—leaves, branches, trees, smoke, water becoming waves, rain becoming vertically horizontal—water turning to sleet and snow— especially snowflakes—drifting upon the currents—the rain we cannot hear in its drifting/ flying flight till it too hits something—the wind soundless in many ways 'til it moves through trees—pushes waves upon the shore. And so it continues on—these great and most beautiful forces of and in nature. (Letter to Ted D'Arms, 10/14/99)

A 1996 photograph, "Mountain Fragment, Mount Shuksan," appears to have been taken from a soaring eagle's perspective; an eagle flying below lowering storm clouds that cast their ominous shadows down onto the snow-covered ridges, cirques, and peaks below. These striated shadows (different from the striated sunlight taken in 1986 at the river) give the impression of speed racing through the frame in several directions. The whole scene seems on the verge of being overtaken

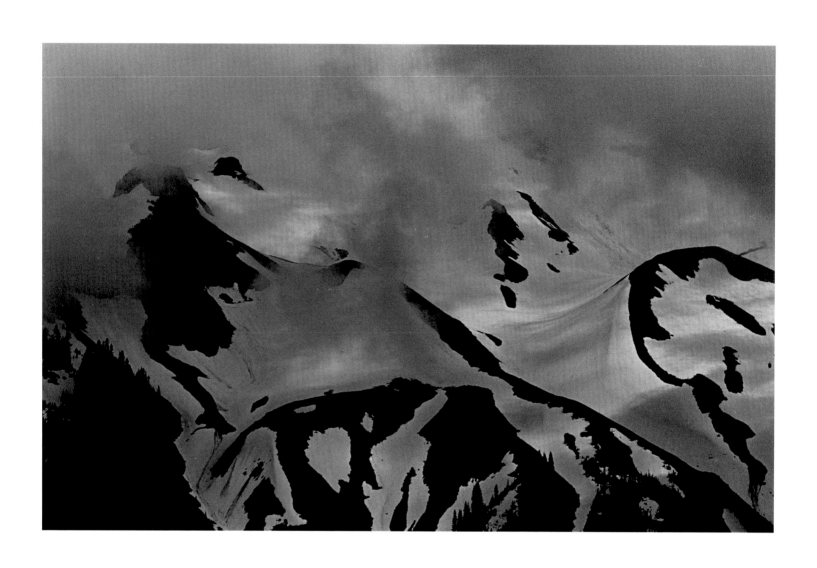

14 / MOUNTAIN FRAGMENT, MOUNT SHUKSAN, JUNE 1996

by complete darkness or a blinding blizzard. Here is a dangerous mountain storm about to happen: the kind of storm man has been warned to avoid at any cost, the kind of storm captured by J. M. W. Turner's apocalyptic paintings of mountain debacles; severe, unstoppable maximum weather conditions. But where is Mary shooting from? Out of a plane? Too dangerous and too close to the mountain. From the back of a soaring eagle? Inconceivable. Better not ask where Mary is when she photographs. This very strange vantage point disorients the viewer and makes the climatic conditions being observed even more threatening and exciting. The black, open areas of rock have been turned into thrusting, jabbing, slashing lines that give the photograph an incredible brooding presence. This mountain top is hunkered down against the weather's assault. High flying storms have battered its height for generations, centuries. But here it still stands—immutable, bleak, impressive. Not subject to man's cleverness, intellect, or spin. Not to satisfy an artist's analogy or theory. Not for anything but what it is—a fact. Mary's photographs cut through to what exists.

Observation by observation, frame by frame, for fifty-five years Mary Randlett has woven a unique cosmology of Northwest light, sky, mountain, ocean, and rivers. But is this a vision of the real world or something she has conjured? Does it exist for others to confirm, or is it something that resides only within herself? She can photograph only what she sees in front of her, but what she sees becomes an external expression of her inner thoughts and deepest feelings. And isn't that what art is, making the invisible visible. Her world is unique, but it resonates profoundly with us and crystallizes experience for us. We recognize the content of her photographs. Their insights trigger complex and affirmative reactions. In our bones, we know her world.

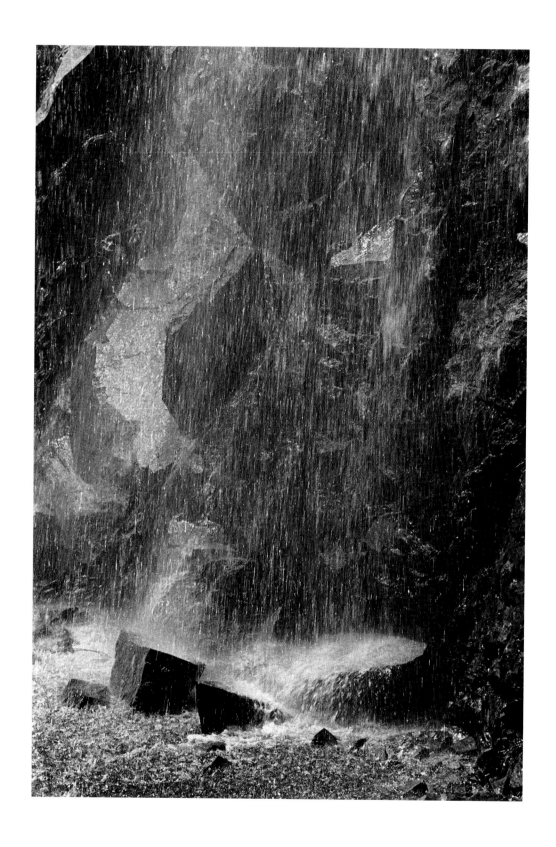

16 / FALLING WATERS, SNOQUALMIE PASS, MAY 1998

Mary Randlett, Friend and Photographer

BARRY HEREM

There is something bigger than fact: the underlying spirit, all it stands for, the mood, the vastness, the wildness, the Western breath . . . search for the reality of each object, that is its real and only beauty; recognize our relationship with all life; say to every animate and inanimate thing brother; be at one with all things, finding the divine in all.
—EMILY CARR, *Hundreds and Thousands*

MARY RANDLETT IS PART OF A TRADITION, AND SHE WOULD easily admit this if it did not mean that she might also have to allow being equal as a photographer to the company of those artist friends with whom she has worked. Oddly, perhaps, they are all sculptors and painters: Philip McCracken, Leo Kenney, Kenneth Callahan, George Tsutakawa, Guy Anderson, Morris Graves, Clayton James, Neil Meitzler, and Donald Frothingham, a roll call of the Northwest's best. But in expressed spirit, in deepest mood, she is closest of all to the Canadian artist and writer Emily Carr and to the nineteenth-century American painter Albert Pinkham Ryder. These and more are the people she admires for their ability and willingness and grit to express their experience by placing nature at the center of it. They have taught her to see and to believe in that seeing—more, they have kept her company in her own seeing as the kind of equal that all artists are who lead the way by showing the rest of us how it's done, deepening by example our own experience of life.

Randlett herself could have written the above remarks by Emily Carr. She has often said much the same to me in the twenty-five years that I have known her. She has written such to me in letters, short spurts of feeling resulting from things we have seen together or sent to one another,

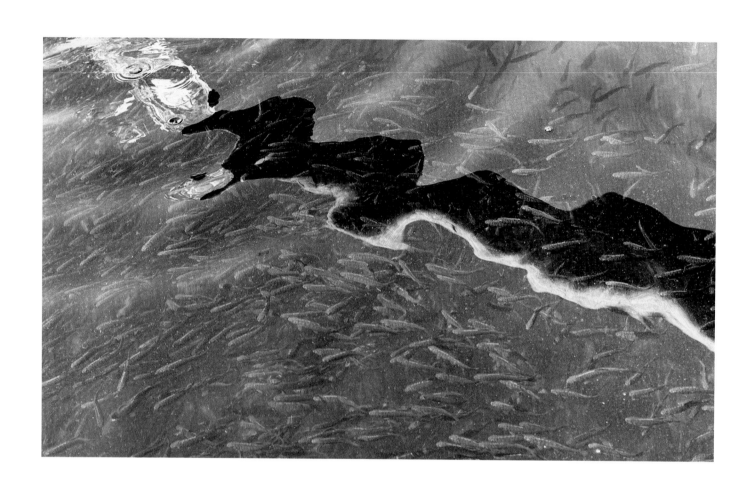

18 / FINGERLINGS, WALLACE FISH HATCHERY, MAY 1967

read somewhere or shared in recollected conversation. She is part of the tradition of feeling which all life-affirming artists know, one of those who appreciates the beautiful moon—moons like Ryder's, she says; one of those who gather in the dappled pool, reflections on water, slow shredding clouds, the sweep of the gull, airy plod of the eagle, the blackness of black shadows, the immanence that stirs and urges everything. Nothing less. This tradition she shares is no less than universal and timeless, to be sure. Byron, Shelley, Keats and all that. But it is also the tradition of women, often older women who through a long life of dedicated effort have distinguished themselves in the arts, leaving a heritage of years lived fully and ardently, a life of striving and courage—always—and a track record of creative accomplishment.

Randlett's particular realm is the Northwest where she has spent most of her life and it is the natural world of Northwestern scenes that she finds most compelling. Yet it is more specific than that. She is in fact what I call a Northwest Coaster, that breed whose life takes us mostly north and south in the realms of the mountains and islands, fjords and sea margins of Washington, Oregon, British Columbia, and southeastern Alaska (all clumsy political abstractions, symbols of a distinct and similar landscape.) It's our Lake District, and Randlett is one of its chief photographers—it's a realm and world, to us a literal demi-paradise. Though it has cities, it is not urban—and you will not easily find cities in a Randlett photograph. The theories of art and photography, the fashions, the rules of art and image which come out of art journals and universities—mostly passing intellectual micro-climates of yea-saying couched in a predictable art-speak—may annoy and dismay her from time to time, as they do any artist who doesn't need to be told what she is doing (long ago she walked out of her one and only photography class), but nothing impedes her experience or inspiration in what she calls subjects that become forms in space. Forms moving through space illuminated by the light of the moment. She has always known these when she sees them and has sought to give permanence to their passing. You see them here in her chosen medium of black and white, the tradition of a photographic chiaroscuro which has satisfied many photographers aiming to present their work in a manner that engages the imagination of their audience as well as their eye. Thus a frame of tiny fish minnowing beneath what looks to be a sheet of ice is far more suggestive than a visual fact. An island suspended above a Zen garden of rocks and tide pool, or a bluff of mountain snow swathed in a portal of clouds arise more as dream visions, as art, than as an unseen photographer's recorded experience. Each are intimations of the infinite, a poetry about essence, which is what Randlett wants to create.

While evocative in themselves, the task of finding these intimations, framing them in a lens or a phrase and recording them is something else. The continual, restless leg work, the drudgery

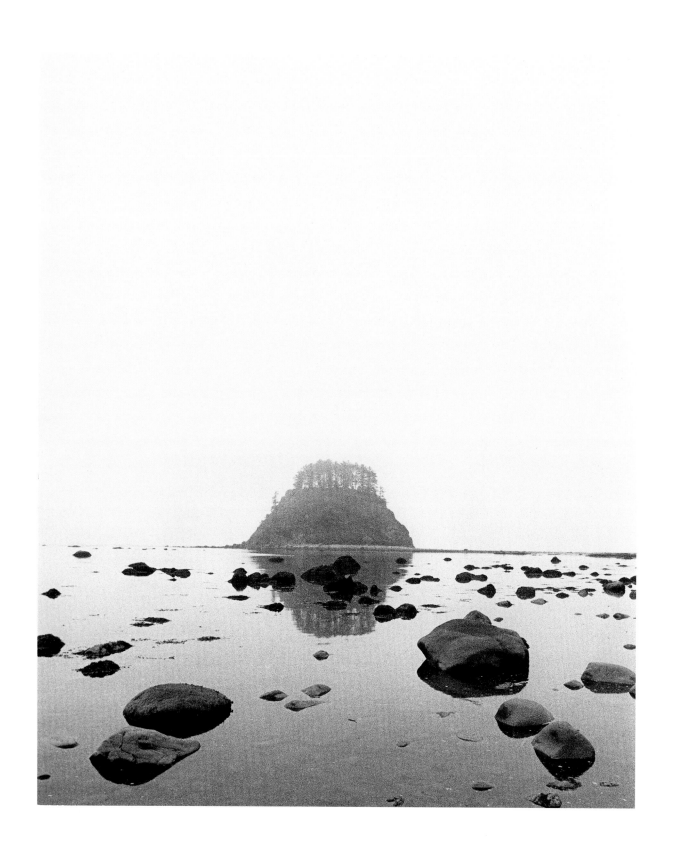

20 / CANNONBALL ISLAND, VIEWED FROM OZETTE, AUGUST 1978

along with the thrill of printing (standing up in a darkroom for hours in Martian-red or amber light), keeping the faith long enough, dragging out the cameras to share them . . . well, that's the earth payment, the real life cost of pursuing and following through on a delicate spirit, on a gift of perception. In her eighth decade, Randlett still works an eighteen-hour day, often all night.

Why?

Well of course it's about love. Love of work, process, result. Love of nature. A passion for these loves. Of course it's also fun and joyous to follow for its result, to follow that strong, sure stirring of energy that leads to embodiment: to create. In photography: to heighten, isolate, suggest, and finally, to share, taking pleasure as reward. There's having to in order to meet a deadline, but you also stand up all night because you want to. These mature photographs, more than any others of hers are about wanting to.

Thus we have a white muff of sea foam leading the margin of advancing shallows. A spent and dying salmon beneath stream and shadow, with what her mother described as a Haida-black in a glossy arc between a foreground wave and a distant island. The shattered path of a hungry swan pressing through the surface of a slushy pond in snowstorm. The strong arms of white trees blanched in a blizzard. Wonderful images. And always reflected light: a lily-bright comet of it on the sand; wrangling ripples of it over the water; a blast of radiance on the far bank; there like buttered fire pouring over the clouds; a gleaming aureole above the open mouth of koi rising to air. Shadow, light, form, reflection, pattern, glowing-black, sun-white, and every gray in mist, cloud, water, stone, spray, flow, and in the smoldering of a savaged forest. Very little action—like nature, nothing superfluous—mostly only light, the principal person in the picture as one of the French Impressionists said somewhere.

Because human beings never seem able to control their effect, rarely as individuals, more rarely still as nations, a photographer like Mary Randlett will likely be considered a historian and preservationist as well as an artist. That would be natural historian in a fully literal sense. It hurts to say it: she takes pictures while there is still a Northwest, the way we are able to see it today at the time of the publication of this book by a farsighted university press. She is a part then of the great remembering which began with the native storytellers and mythic mythmakers of the Northwest Coast. These forebears in the landscape told of its mythic makers and primeval denizens, its first citizens—Raven the creator and trickster and all his animal hosts. They are the proto forebears, all traditionally viewed as ancestors of the First Peoples. Randlett's photographs, these photographs, comprise then an anthropology, the ethno-landscape of our time as it shall not be again. It seems there are to be many fewer forests, many more houses, highways, and cities. Many more

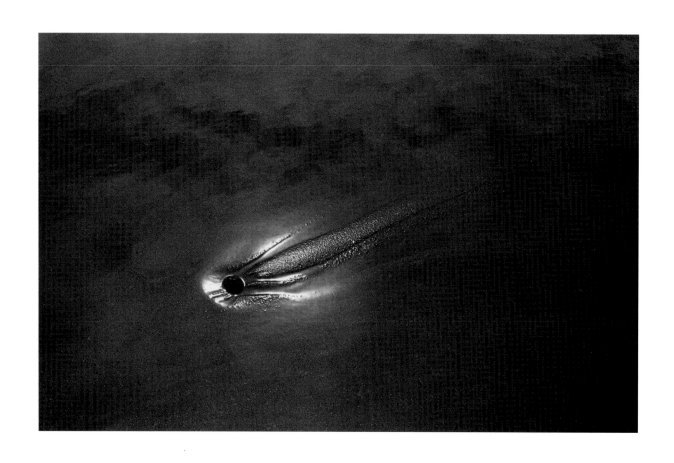

22 / COMET, LA PUSH, JULY 1991

people. Fewer uncluttered shorelines to photograph in the rising day of mist and cloud and valorous light. Already a century ago her forebears knew this and did their conscious work as the region's first photographic recorders, rendering images of a far more primeval landscape than we can easily imagine. Darius Kinsey, Edward Curtis, Asahel Curtis, and many more strove to record the changing landscape of their time, the vitality of its new people, Anglo-pioneers, and its then dwindling Native American populations.

It is significant to say that the photographs in this book have not, for the most part, been wage earners for Mary Randlett. They merely represent a love of the present for what it is. They leave no hired record of logging camp operations or significant construction sites. They are natural scenes, the closest to her heart, which pay back no more than the benefit of delight and rapture. They are, nevertheless, seriously of her time because in her time landscape and environment have come of age, recognized in their eleventh hour as truly sacred and wholly irreplaceable ancestors of all that lives. I look at these photographs then as a slim record of our genesis and cradle, pathway, place and pride. For this alone they can be cherished. In their stillness and joy-of-light we see our larger house, the planet, as both imperiled mansion and hallowed hall.

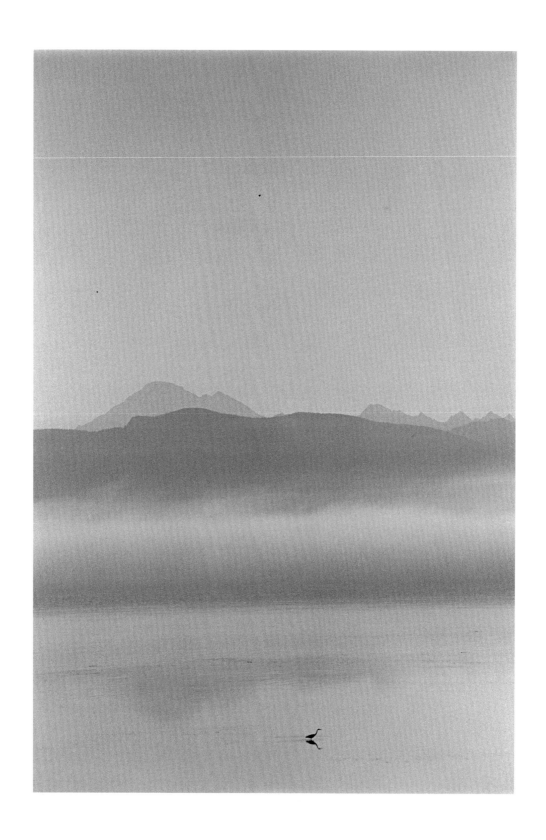

24 / STILLNESS, VIEW FROM GUEMES ISLAND, APRIL 1990

The Art of Mary Randlett

DENISE LEVERTOV

ELL KNOWN THOUGH SHE IS IN THE NORTHWEST FOR HER documentary work—the photographs of Seattle architecture, of art in public places, of writers and artists, and of the works of various visual artists—Mary Randlett's own essential creations, her poetic nature photography, have remained virtually unknown except to her friends.

She is a woman in love with light, as a poet is in love with language, and so the camera is to her what the pencil is to the poet, the brush to the painter. But while this love affair with light must be common in some degree to all photographers, Randlett's passion is intensely focused on the role of light in the landscapes of the Northwest—light on water, light in forests, light on mountains, on ice, on snow, on clouds and mist. In contrast to her documentary photographs, those which constitute an homage to nature do more than record, they express her lyrical vision.

I was happy as can be, all alone, searching, finding that beautiful light and then seeing what forms emerged—and the backgrounds of subtle form—bare trees—happy, happy. The following day I decided to head toward Rockport where the eagles are. I went on a road new to me, to Arlington along the river, stopped at Jordan Park, down to the river, ice, snow . . . no one anywhere—silent flowing river, on surface floating ice in pieces like clouds in sky—and beneath the floating, another depth. Beautiful, long shadows of trees from the other side of the river— abstract—so: the ice as clouds, the river itself flowing over the tree-shadows. Crossed an old one-car bridge, parked, heard a thud as some rocks came rolling down from the steep hillside. Took pictures of the ice from the bridge. Of course I never know what I'll get, but the Seeing is the first great moment.

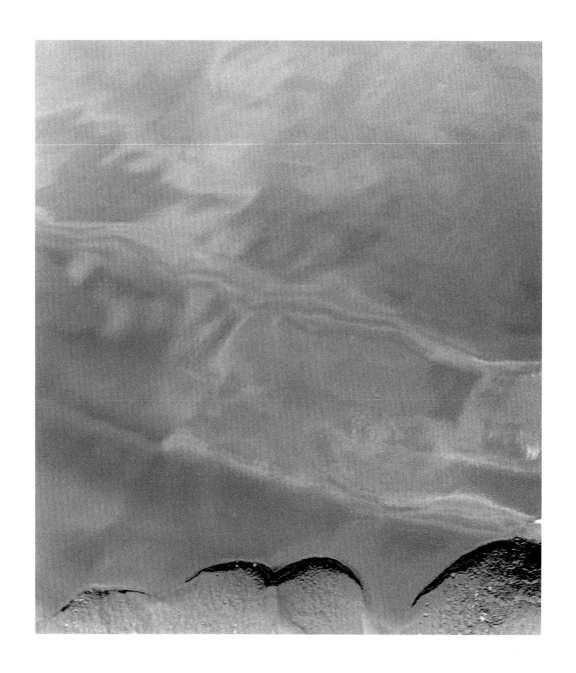

26 / WAVES AND REFLECTED SKY, AUGUST 1988

When I first met her and had seen only a few of her images I asked her if, with her appreciation of the wonderful colors with which the natural word surrounds us, she didn't feel tempted to use color film (especially now that it can produce more subtle and accurate results than was once possible). I soon came to realize that it was a foolish question, for her artistic interest is concerned with capturing *values,* the spectrum of *tones,* not with the *reproduction* of what is to be seen. She seems to have had instinctively, from the beginning of her creative enterprise, the knowledge (so important an element of aesthetic success) that the artist in any medium must be concerned with *re-*presenting, not with attempting *duplication* of the things that are the given origin of a work. Thus in her nature photographs, Randlett has consistently stayed with "black and white," for beautiful though some contemporary color photography is, it unavoidably gives color itself center stage, while only in black and white does the subtle range of tones (barely noted in our ordinary viewing of a colored world, but apparent to the vision of an artist like Randlett) show forth. It's almost analogous to seeing under a magnifying lens the otherwise unknown forms and textures of things we take for granted as normally perceived.

Here and there on the distant peaks the ice glowed, reminding me of the liquid light I see on the water. . . . At the turn-off, peeking through the stark woods the river was swollen with melted grey-green glacial waters, flowing silently towards the bridge. I came to a huge cedar tree. . . . I measured it off about 7 feet in diameter. A solitary reminder of what the forests would be like today if white men had not appeared. There are beautiful boulders, moss-covered, here and there in the river bed . . . surrounded by swirling white waters. Then beyond . . . a white staircase of water at the bend of the river [as if manmade but] far more beautiful. The white water cascaded down these beautiful stairs and just down the river next to this swirling mass of water a quiet part. Large rocks looking like pebbles on a beach with water silently moving around [their] shining wet [surfaces]. A Yin-Yang . . . dark against light.

Randlett has a special gift of catching a never-to-be repeated instant out of the flow of time, a gift inseparable from the professionalism of always having her instrument, the camera, at the ready, but also compounded of a vigilantly alert visual attention.

I went by myself in my house on wheels and was so happy I could hardly stand it, dreaming, looking for all the unknown which might appear or not . . .

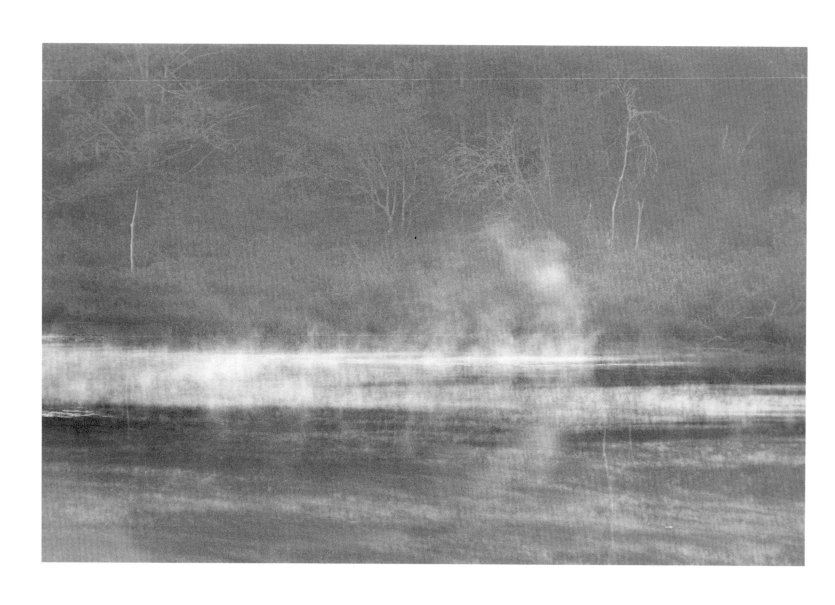

28 / ARCTIC SMOKE, DECEMBER 1978

We associate this gift more often with photographers of persons, not of nature (I think particularly of Cartier-Bresson) and tend to assume that landscapes "stay put," changing only with the relatively leisured changes of weather and season, unlike the rapid movements and gestures of unposed human subjects. But in fact, and especially in the variable moods of the Northwest, the effects of light for which Randlett has such an eye happen extremely swiftly.

Today as I write you I am at the end of a 10-mile road . . . which traveled up up up through clouds out into a world above the other mountains. . . . I have a view of the Olympics to the west, through the foothills north down to the straits, and to my east of a very very distant cloud-shrouded Mt. Baker—my ideal day—I left in the mists and now the sun comes and goes among clouds as do the beautiful mountains becoming fragments—no one is here—the first level ground since I left the highway—only a blowing wind, moving trees, and emerging mountains from mists. When I arrived here I opened the door and there 15′ away a doe, tame, and she's still here. Mists are coming in from the east—view totally obscured so I must leave while I can still see the 1–way road. The air is cool . . . not a sound—no birds even. . . . Before me cloud shadows move across the very steep slopes before me, passing over me, hiding the sun—almost like a bird shadow at times. It is here in a place like this that I know great elation and subdued peace.

As these quotations from her letters reveal, Randlett is not by any means a sort of mechanism, like some virtuosos in various artistic media sometimes seem to be—a sort of extension or function of their instruments, alive only in the performance. Her hardly legible, eccentrically spelled scrawls, punctuated mainly by dashes, are often of many pages, and their spontaneous eloquence articulates a highly conscious enthusiasm for the beauty she is so quick to see and feel—above all in Nature, but also in the arts and in ideas. I know no one more full of joie de vivre, and no one with a stronger eagerness for continued learning. She is extraordinarily open to new experience, new people, encounters with new paintings or poems, discoveries in listening to music. She reads widely and discriminately, yet with the kind of excitement we associate with youth.

I get caught in the grasp of exciting words that play in my mind and fire huge imaginations. Have I ever seen a Rain shadow? No—How can I find one to photograph—something to give that essence?!! [or] 'the complexity of a rain-drop'?—have had that written down for several years, it haunts me—when can this come out in my work—how is it all possible—so as you know my mind is always churning.

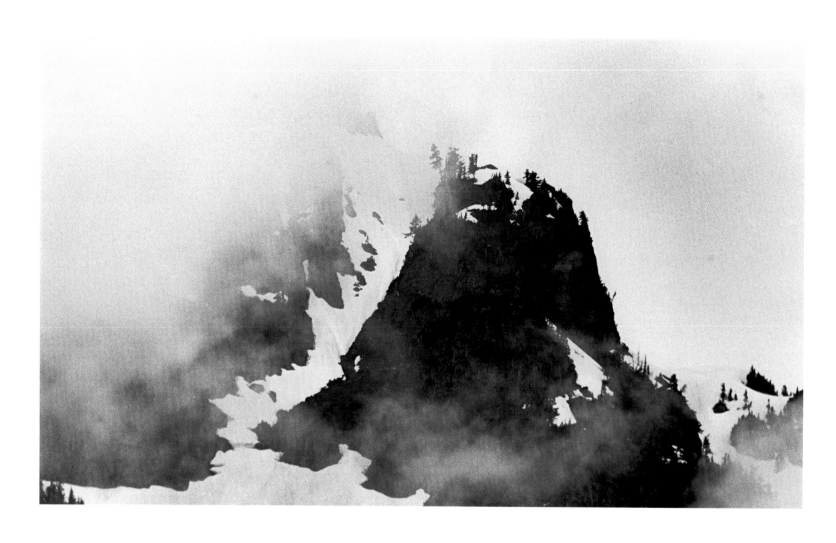

30 / VEILED MOUNTAIN, NEAR MOUNT BAKER, JUNE 1996

Yet this ebullient energy, this capacity for joy, while making possible the abundance of her oeuvre, doesn't confine its distinctive look to anything resembling a simplistic celebration of self-evident beauty. On the contrary, there is an austerity and often a somber quality to so many of these images. Winter, with its stark forms, seems more often her season than opulent summer; and earliest light, when "arctic smoke" rises off the rivers, and the wonderful mists of this region, which at almost any time of year play at veiling and unveiling woods and mountains, appeal far more to her, as an artist of tones and values, than the blaze of noon and the height of summer which challenge and delight a colorist. And in her revelation of ephemeral wonders, the craft lies in detaching the image from its background—not by subsequent darkroom processes but by the swift decisive choosing of the exact moment and her position in relation to the thing seen.

[In photography] an image must separate out from a background, a vast background at times —that image all at once becomes . . . a Form moving in Space—through Space illuminated in light—and at that moment (differing from a painter of the same scene) I must take all that is there, eliminating through light and shadow, slight movement, and placing, any unwanted objects. The painter simply doesn't paint in what he does not wish. . . . The photographer is coming from the opposite pole from the writer. The writer starts from wherever [the poem] starts, invisible to the [reader], and then, as you . . . say, "makes its way into daylight, out through arm, hand, pen, onto page"—the photographer starts with a total huge image [from which] the object of interest must be separated, deleting rather than adding.

Finally, it is important to recognize—as this book will enable a larger public to do—that Mary Randlett's work is important in two ways: infused as it is with the spirit of the Northwest (where she has lived all her life), it heightens our sense of what will be lost, here as elsewhere, if we do not stop despoiling the forest, building suburbs on once good farmland and malls in wetlands, fouling the air with automobile fumes, poisoning the waters with poisonous wastes. Randlett's tribute to the great beauties of this area stimulates the resolve to preserve them, although that is not due to any conscious agenda on her part. The other, and timeless, factor in her work's importance is that these are *compositions*—that is, they are harmonious yet dynamic dispositions of forms and values, and in that sense are abstractions, not illustrations; or, to put it differently, they are not merely accounts of something else but are things-in-themselves, that is, autonomous works of art. And one of the great paradoxes and fascinations of art is the way in which it *can* combine these seemingly incompatible factors of representation and the abstract design.

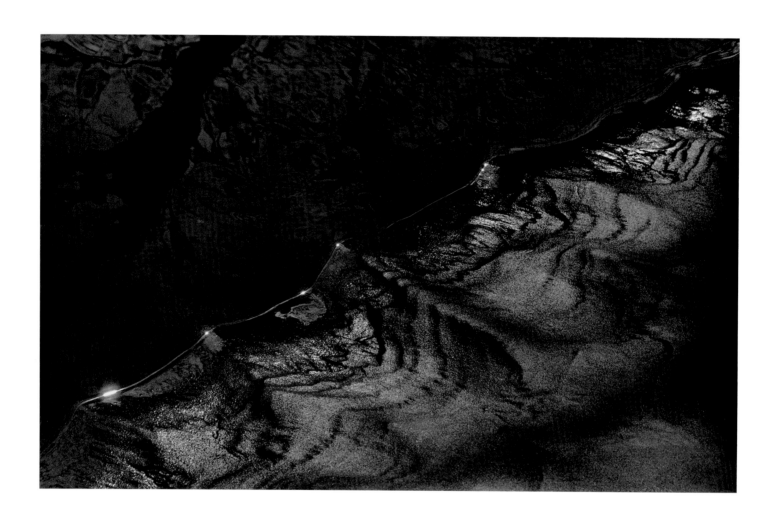

I would like Mary Randlett herself to have the last word, in two more excerpts from letters:

To see the movement of water in this lake one must look at something like this rock to get the light right and the level of viewing—suddenly the waters start moving, ripples form, the clouds move in and away across the island, outlined in light like ice. Get down much lower, all movement stops and the whole scene is a liquid white. Playing with light, form and movement in space—I simply get lost, time stops.

In that passage I note the way in which, for a true artist, the thrill of vision is inseparable from the consideration of how to convey it in the terms of his or her medium. Craft is not a separate compartment of the artist's apprehension.

And in this last one occurs a mention of that bonus, the "more than one knew" which an artist in other mediums may sometimes receive but which is perhaps most clearly evident, though not necessarily more frequent, in the experience of a photographer, whose camera may have picked up some detail the naked eye had not perceived but which enhances the total image:

I step into that great mysterious beauty and behold a world of total magic that unfolds before me—nothing else exists, nothing else matters. I am at one with the world before me, the one I'm totally in—almost like making love—and when I come back I literally unwind, step back, step out of the world where I was—what becomes of what I saw, so . . . etched upon within my visual mind—[it] awaits quietly, unknown within the film [where] I tried to record all these bombardments of happenings—Beauty—When an image appears as I saw it, it sends chills rippling up and down my spine, and . . . when there is more than I saw within an image I simply thank that Superior Being—God, Nature, whoever—for the gift. I don't question anything—I feel simply blessed—and most thankful—to have been given this gift.

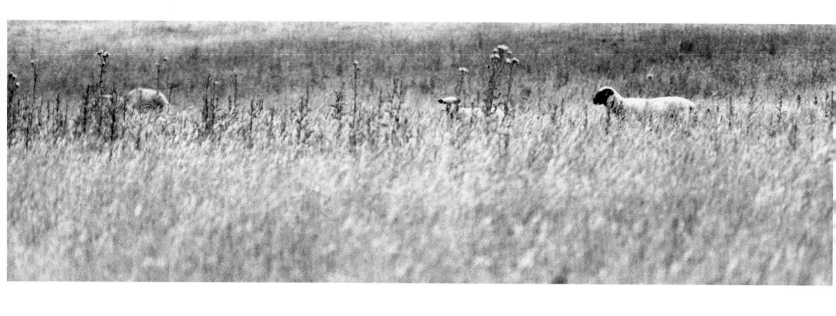

34 / SHEEP IN THE WEEDS, ORCAS ISLAND, JULY 1971

Sheep in the Weeds

Simmer and drowse of August. And the sheep
single file
threading a wavering path, because
the mood takes them, or took
the bellwether, to go
this way, not that,
the length of the long field.
Coarse grass,
a powdery green. Hum
of bees, heat of noon
among seeding thistles. Silver,
purple.

Almost bodily
something returns,
a heavy
note or two of sensual music.
A moment
of milkweed sweetness
long past,

a river
unseen beyond
the field's vague edge.

Without nostalgia,
a neutral
timelessness. Its shadow,
still tight as skin around it,
rehearses in silence
the message
it will deliver later,
about time.

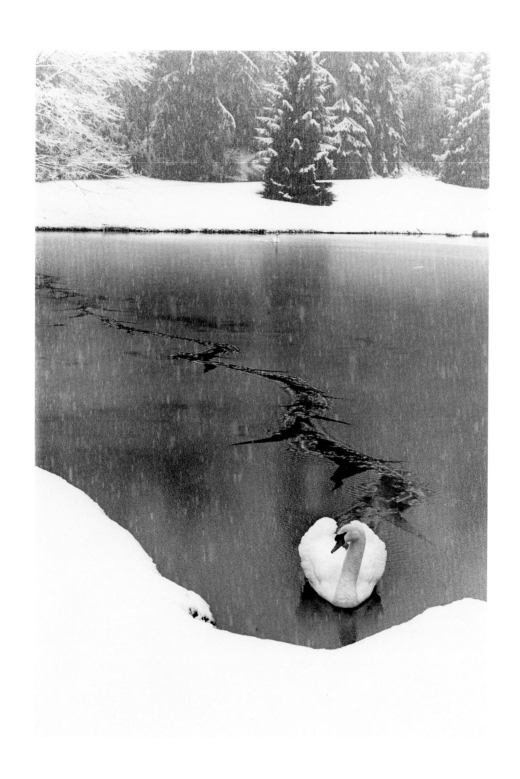

36 / SWAN IN FALLING SNOW, DECEMBER 1984

Swan in Falling Snow

Upon the darkish, thin, half-broken ice

there seemed to lie a barrel-sized, heart-shaped snowball,

frozen hard, its white

identical with the untrodden white

of the lake shore. Closer, its somber face—

mask and beak—came clear, the neck's

long cylinder, and the splayed feet, balanced,

weary, immobile. Black water traced, behind it,

an abandoned gesture. Soft

in still air, snowflakes

fell and fell. Silence

deepened, deepened. The short day

suspended itself, endless.

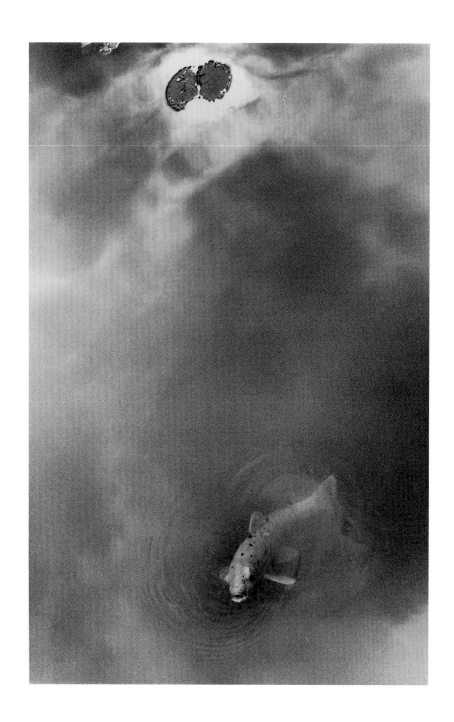

Firmament

Fish in the sky of water—silverly
as travelling moon through cloud-hills—
down current whisks, or deeper
fins into depths, to rise or sagely
wait in the milky mist of
disturbed sediment, wheeling briskly
at least whim, at one
with the aqueous everything it shines in.

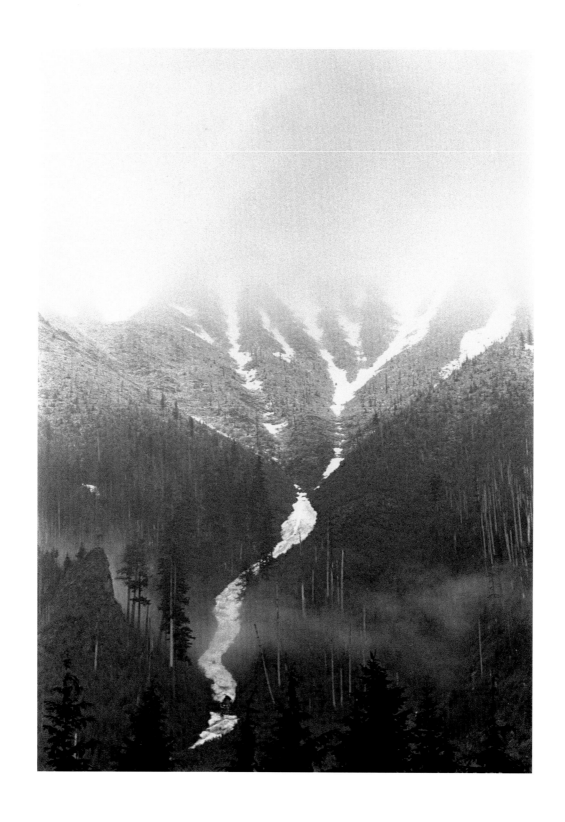

40 / ON THE WAY TO SNOQUALMIE PASS, MAY 1994

Double Vision

Artery of ice,

winding sinuous down between

scarred hillsides, remnant

forests, clearcut raw

scraggy declivities. Above,

pale capillaries mark where,

when it thaws, this

frozen stream will take

the thin soil down with it.

Meanwhile it lies

white on gradations

of nuanced grey,

flowing to black, elegant design

to be acknowledged,

detached arabesque, a beauty

not to be denied.

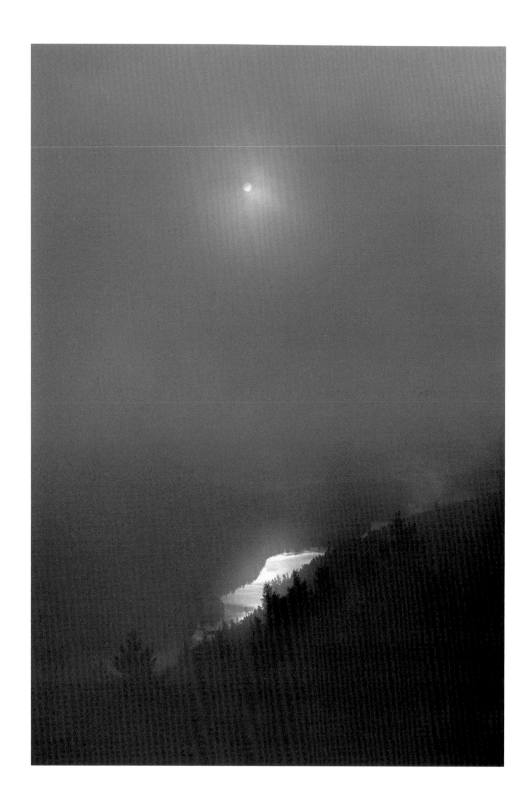

Alchemy

Deep night, deep woods,
valley far below the steep
thigh of the hill, the sky too
a hazy darkness—yet the moon,
small and high, discovers
a wide stretch of river
to be its mirror, steel
brighter than its own
fogmuffled radiance.

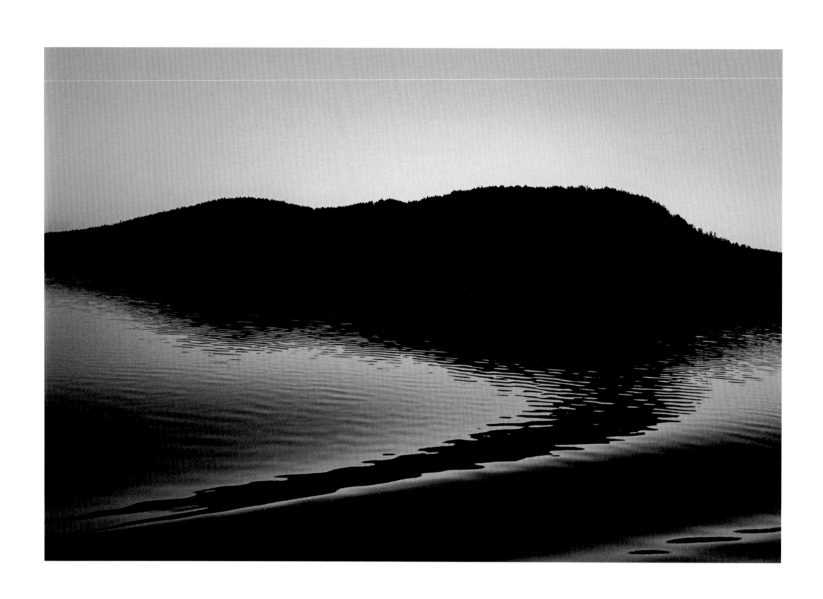

44 / ISLAND WAVE, AUGUST 1990

Warning

Island or dark
hollow of advancing wave?
Beyond
surf and spray a somber
horizontal. As if the sea
raised up
a sudden bulwark.
A menacing land, if land—
frowning escarpment, ephemeral
yet enduring, uncharted,
rumored. If wave,
a thundered prophetic word
in ocean's tongue, a bar of blackest
iron brandished aloft
in two fists of a water-god,
a warning not meant kindly.

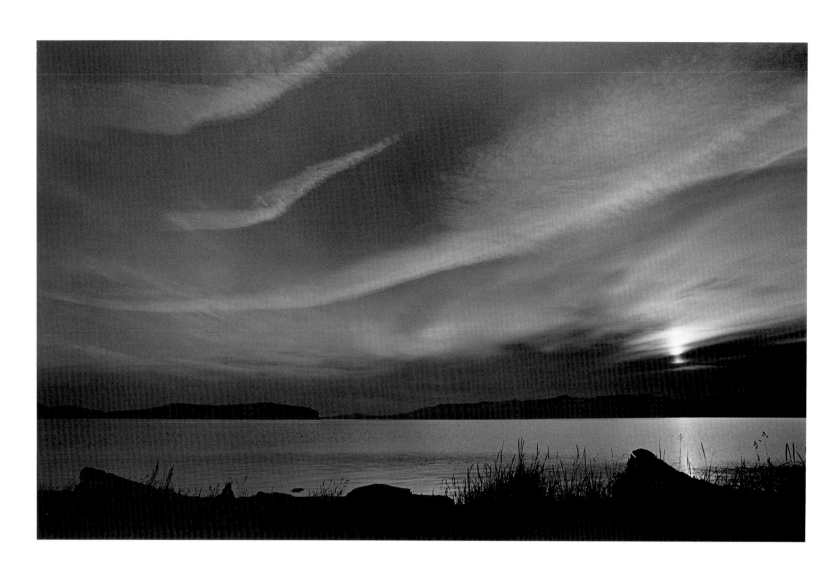

46 / GUEMES ISLAND SUNRISE, JUNE 1996

Agon

The sea barely crinkled, breathing
calmly. Islands and shore
pure darkness, uncompromised,
outline and mass without
perplexity of component forms,
the salt grasses at water's edge
a frieze, immobile. All of this
a visible gravity,
not sad but serious.
 And above,
the light to which this somber peace
has not yet awoken, the sun
struggling to rise as one fights sometimes
to break out of fearful dreams
unable to shout or move—and clouds
in delicate brilliance sweeping
long aquiline curves, wild arabesques
across the east, drinking the rising
light, light, as it streams
out from that mortal struggle from which
the sun is already gasping free.

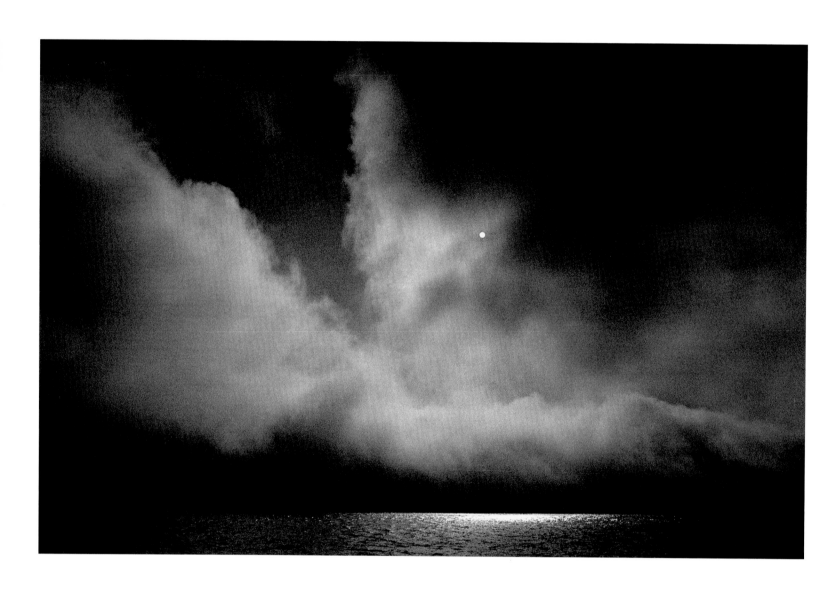

48 / WESTERN SPLENDOR, FROM BAINBRIDGE ISLAND FERRY, MARCH 1993

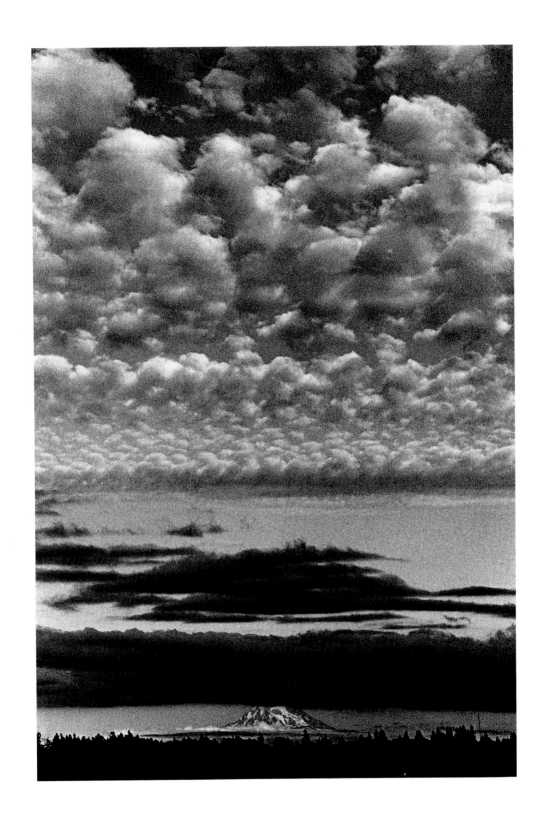

49 / VIEW FROM WEST OLYMPIA, NOVEMBER 1998

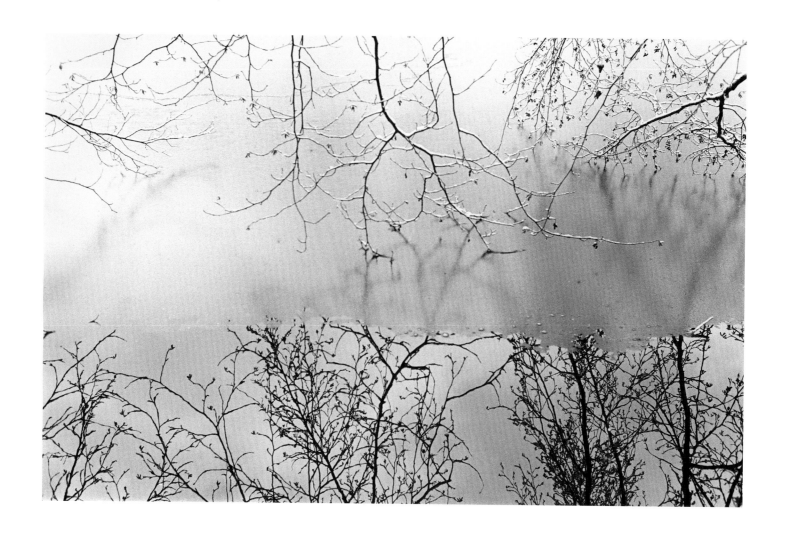

50 / WINTER, BLOEDEL RESERVE, BAINBRIDGE ISLAND, JANUARY 1992

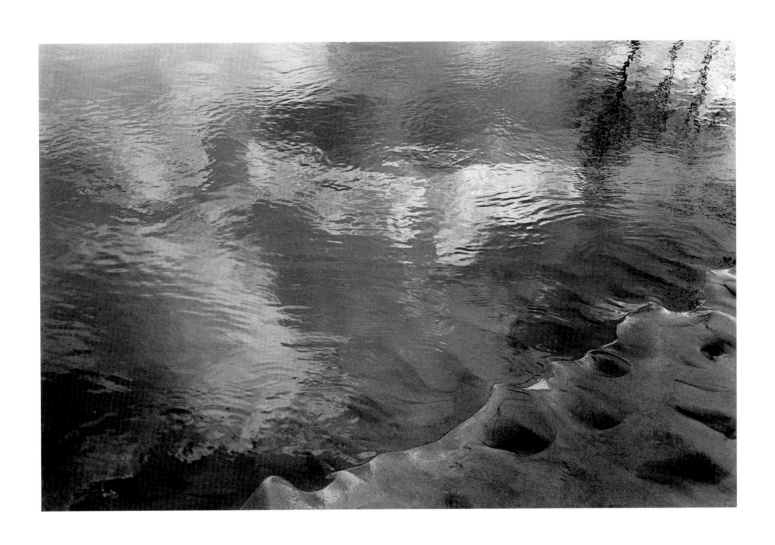

51 / SKAGIT RIVER 1, FEBRUARY 1991

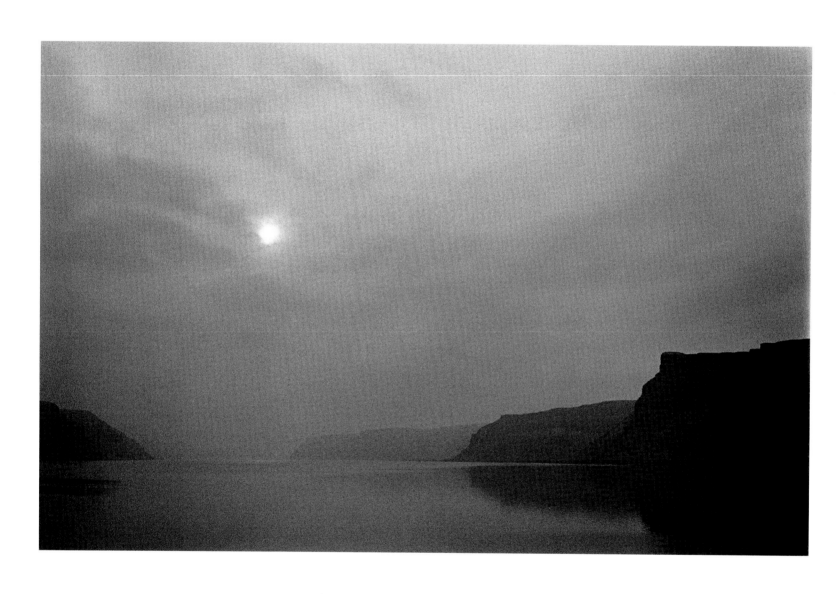

52 / WALLULA GAP, NOVEMBER 2004

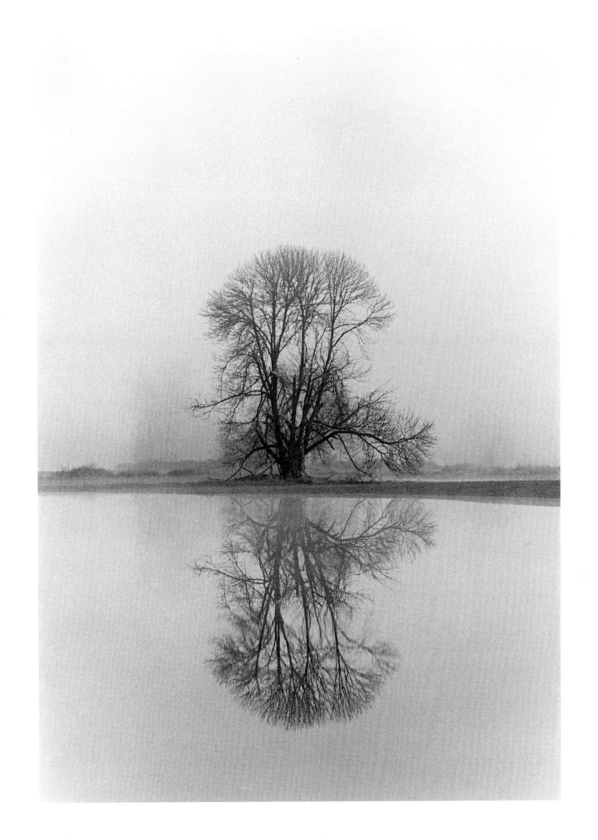

53 / FLOODED FIELD, NOVEMBER 2006

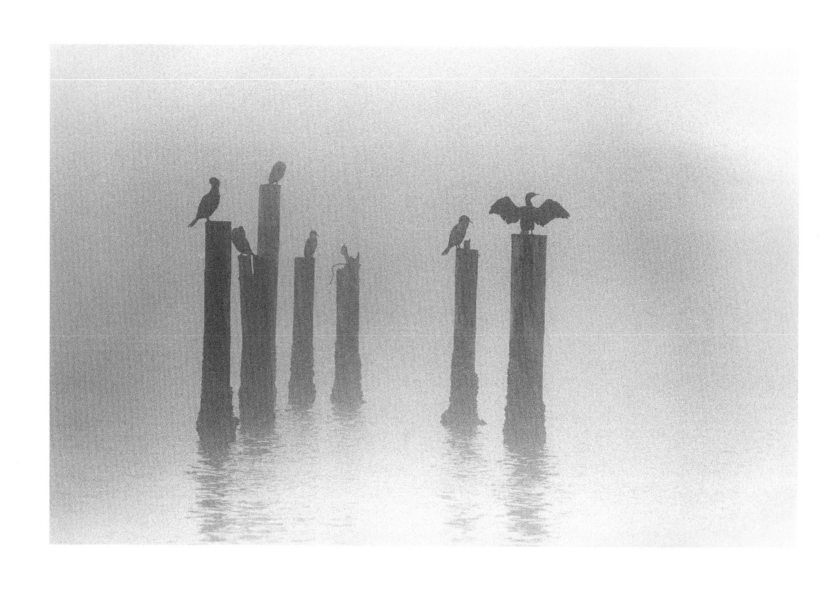

54 / AGATE POINT, DECEMBER 1988

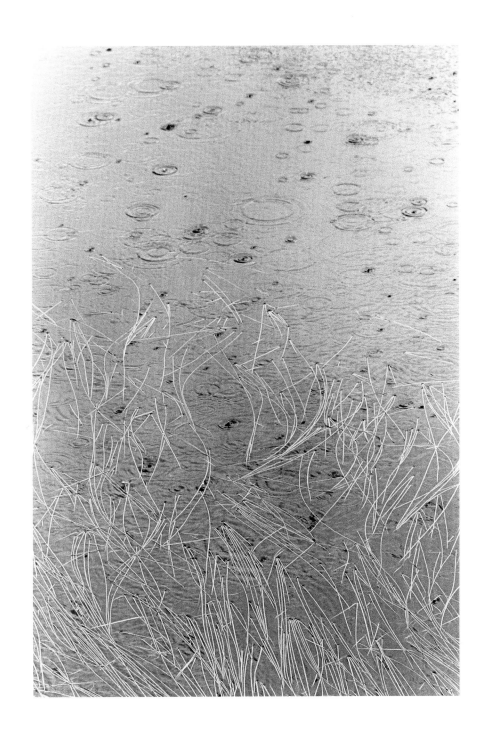

55 / LAKE AT MOUNT BAKER, OCTOBER 1971

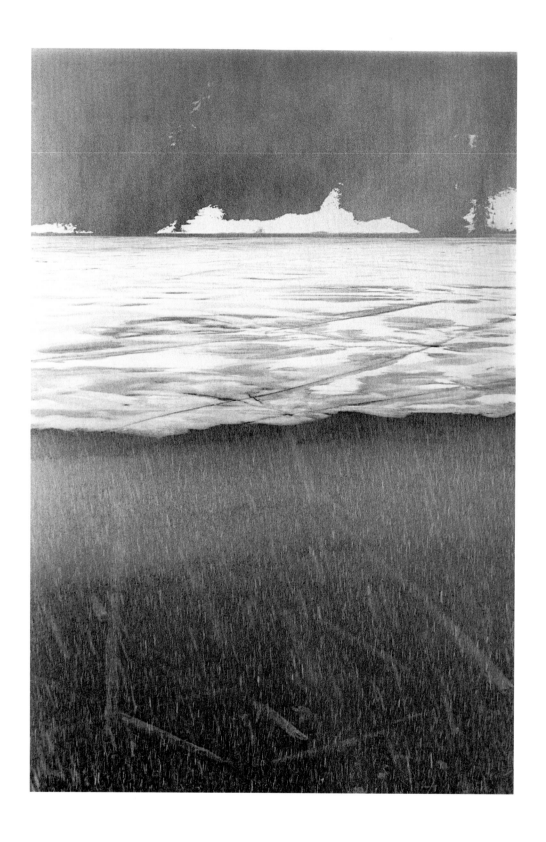

56 / FROZEN LAKE NEAR WHITE PASS, MAY 2000

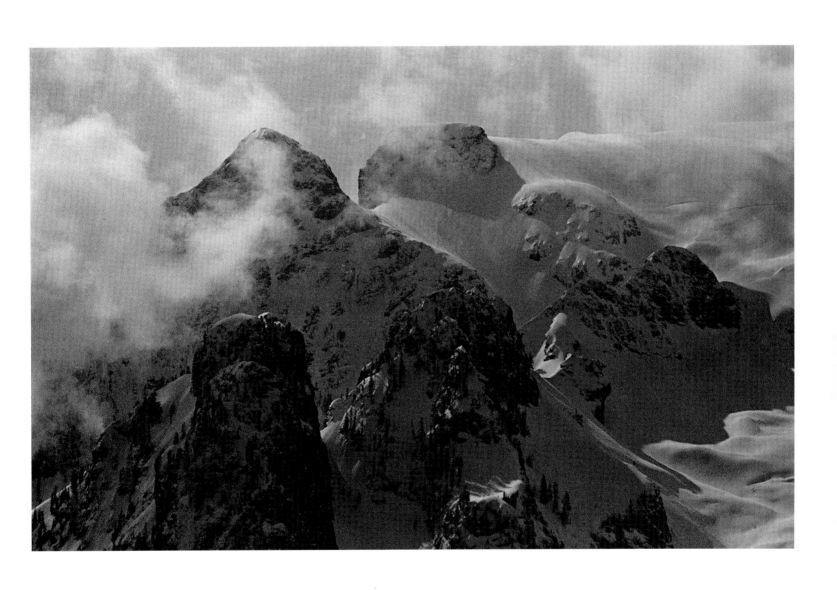

57 / NORTH CASCADES, APRIL 1996

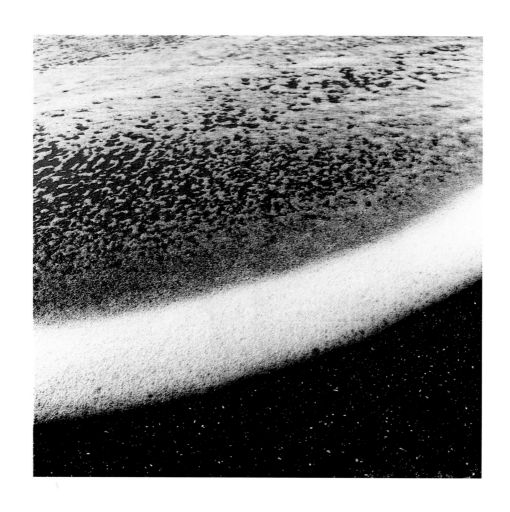

58 / OCEAN BEACH, OCTOBER 1967

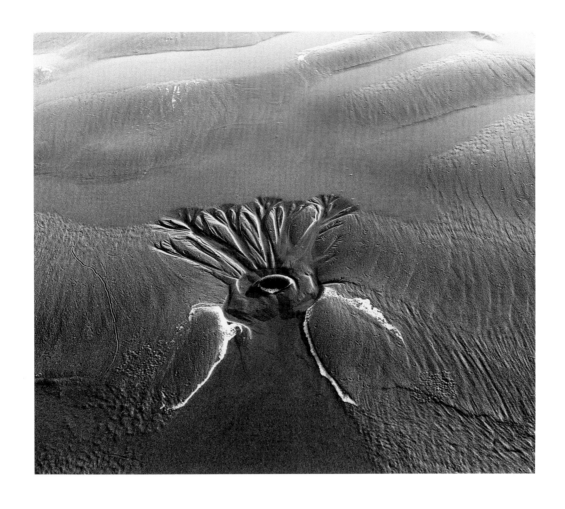

59 / SAND PATTERN, OCTOBER 1964

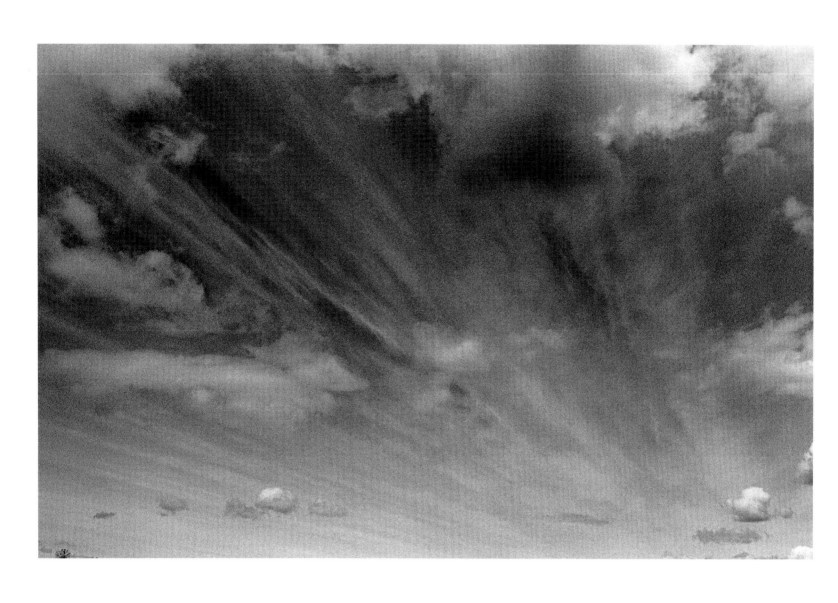

60 / CLOUDFORMS, NOVEMBER 2003

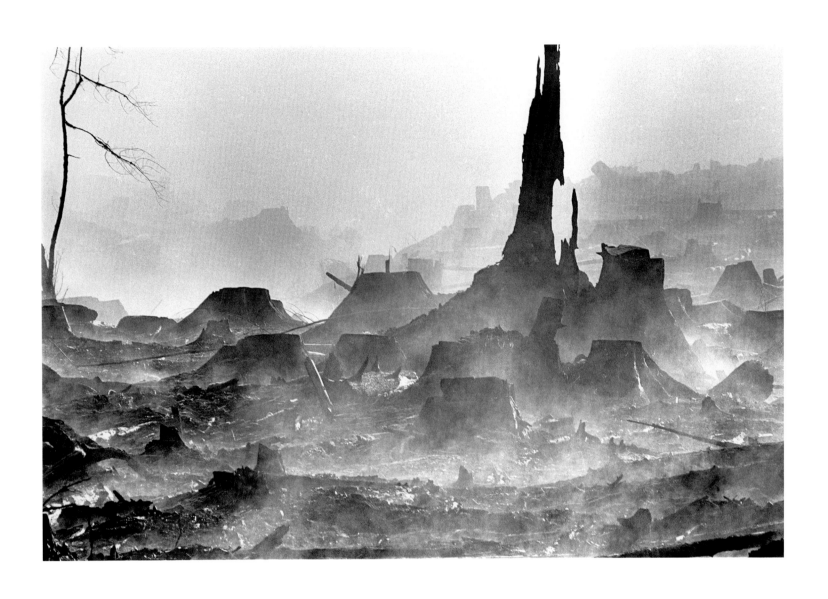

61 / CLEARCUT, COASTAL HILLS, DECEMBER 1987

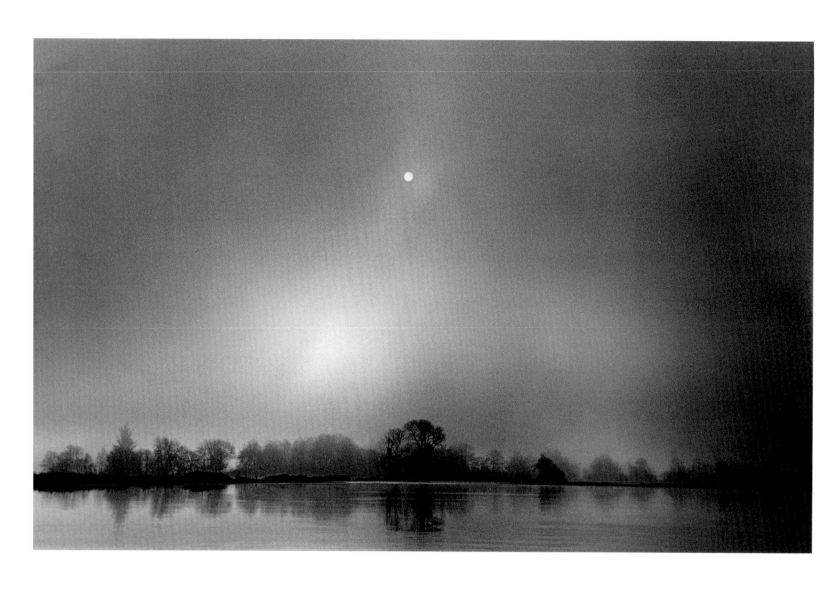

62 / FLOODED FARMLANDS NEAR ELMA, NOVEMBER 2006

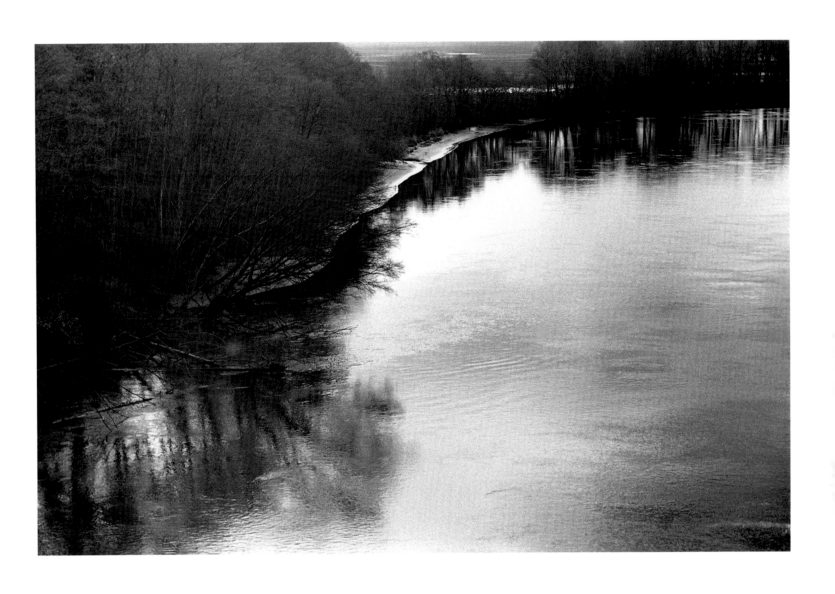

63 / SKAGIT RIVER 2, FEBRUARY 1991

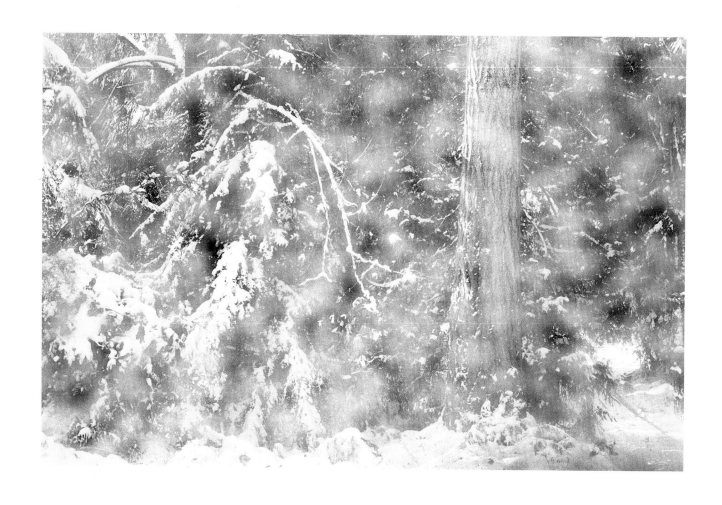

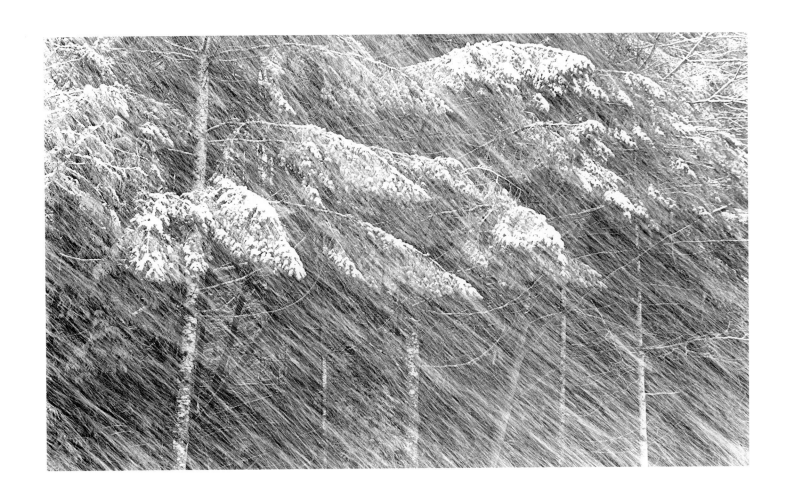

65 / EARLY WINTER, OCTOBER 2004

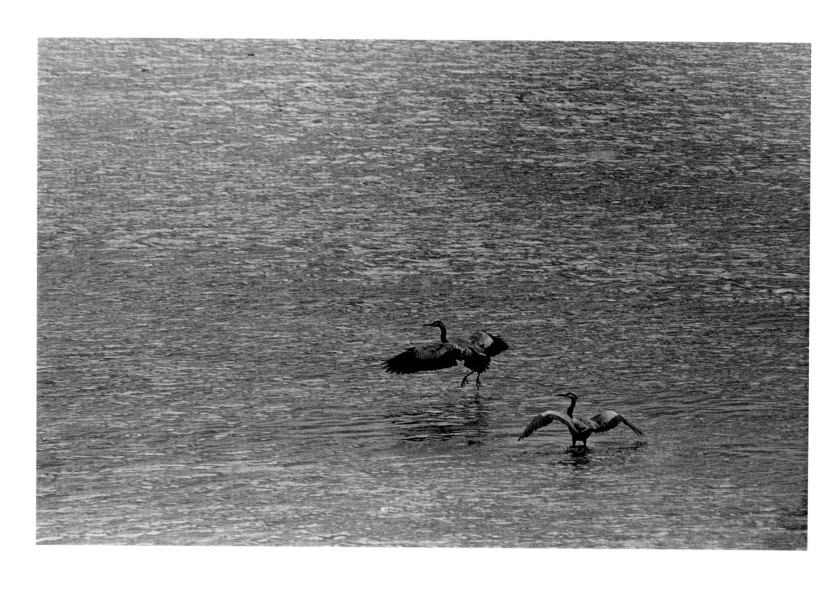

66 / HERONS, JUNE 1996

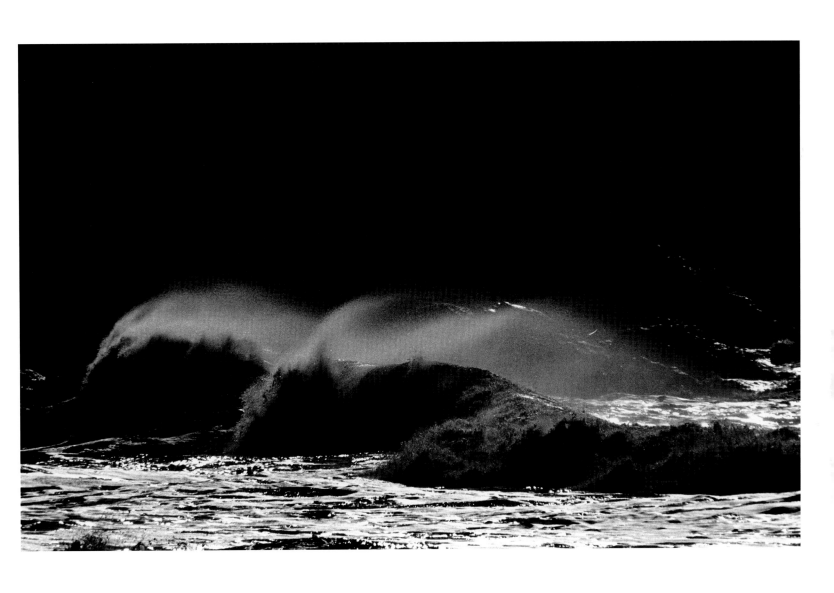

67 / BIRD OF THE SEA, LA PUSH, JANUARY 1995

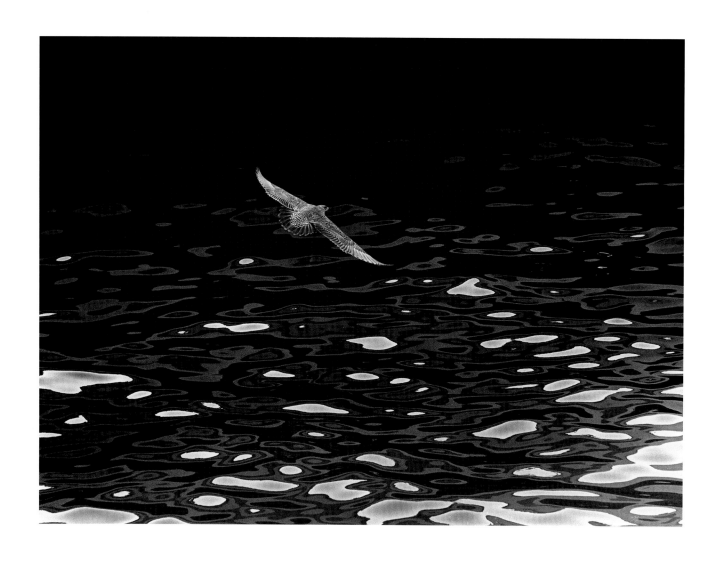

68 / OSPREY, SEATTLE WATERFRONT, MARCH 1968

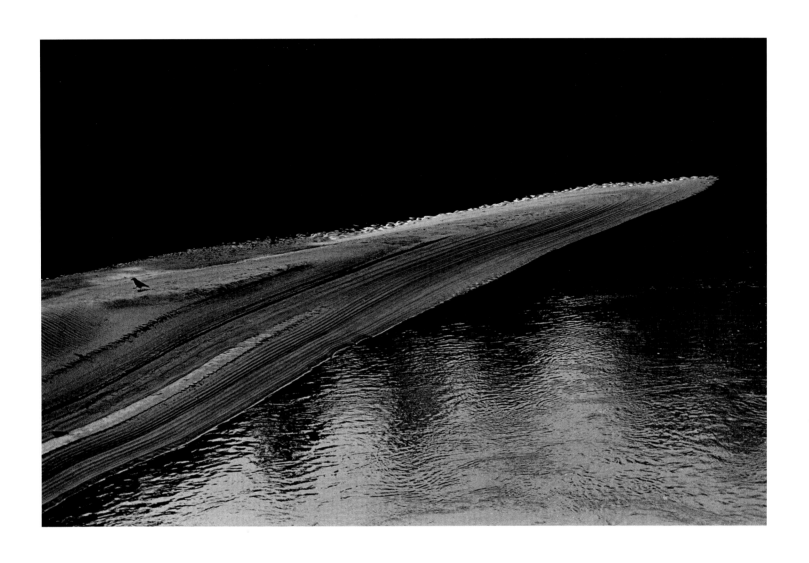

69 / SANDBAR, NOOKSACK RIVER, MAY 2005

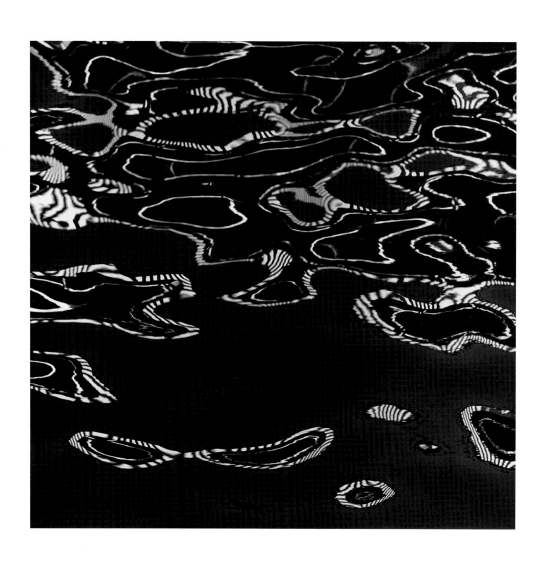

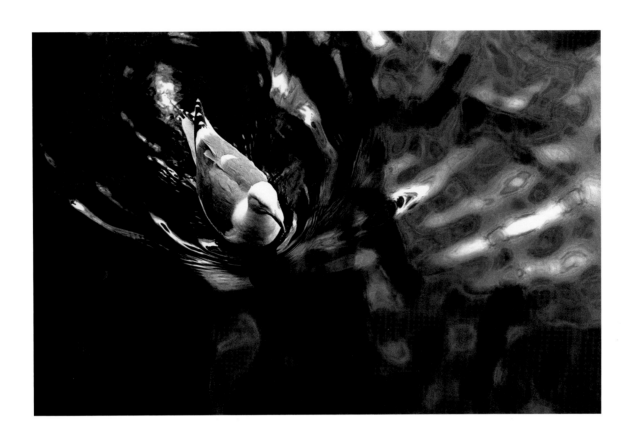

71 / SEATTLE WATERFRONT, MAY 1993

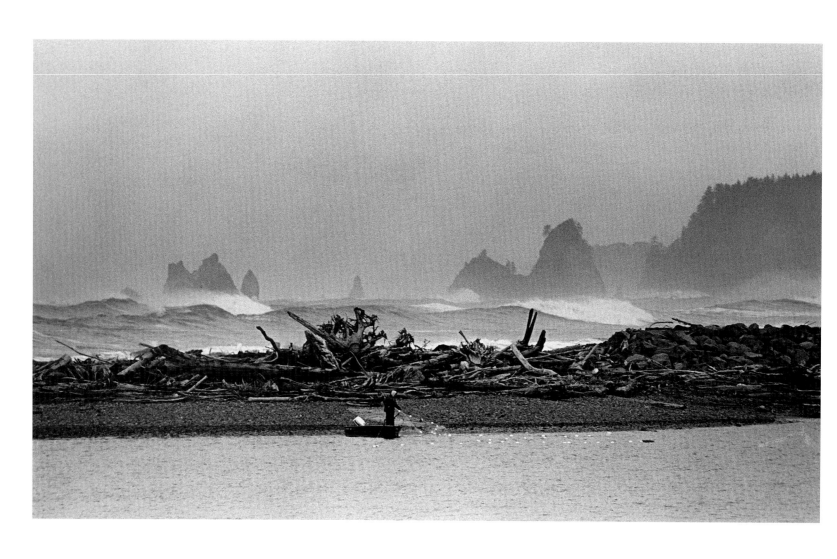

72 / VIEW OF RIALTO BEACH, JANUARY 1986

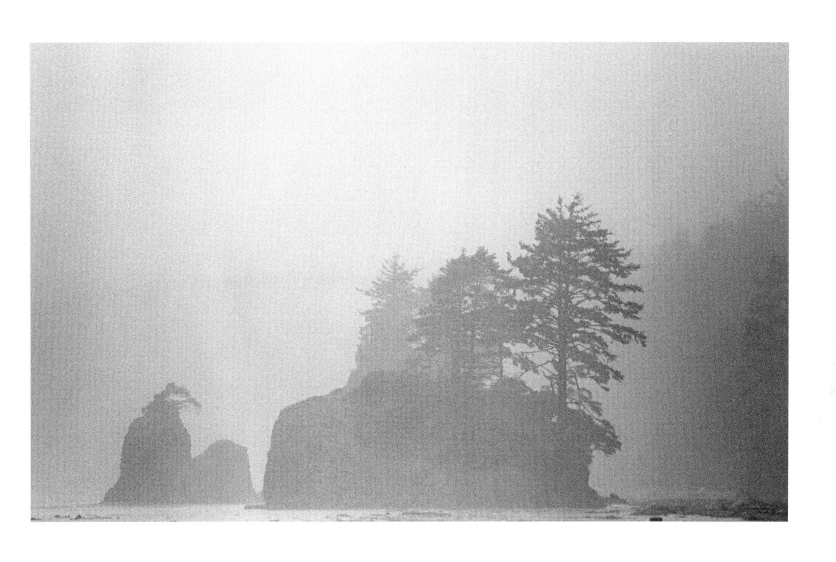

73 / WASHINGTON COAST, NOVEMBER 2003

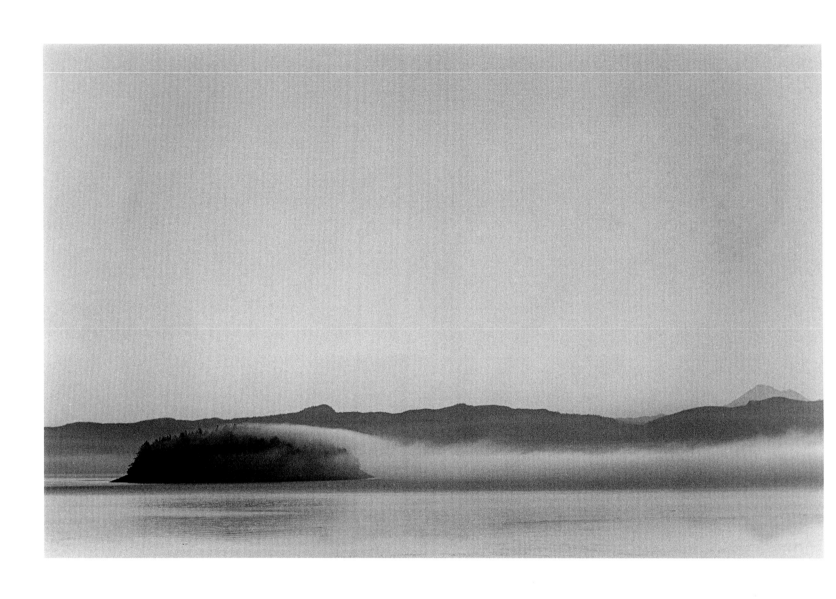

74 / JACK ISLAND, APRIL 1990

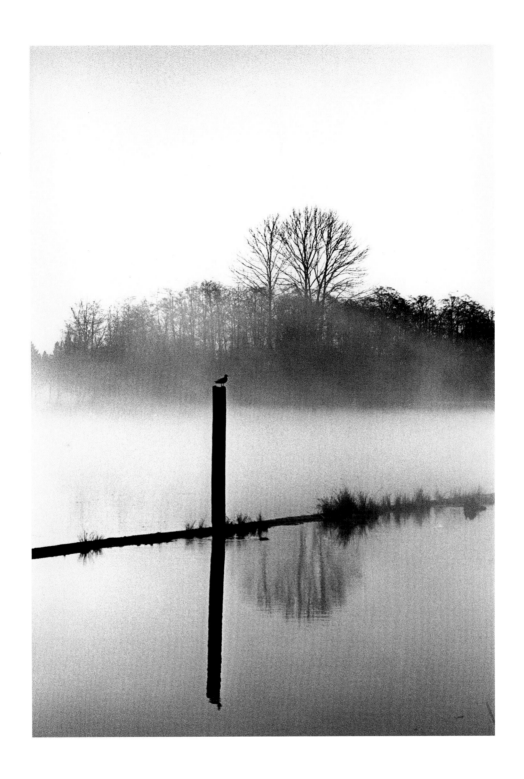

75 / EVERETT SLOUGH, FEBRUARY 1993

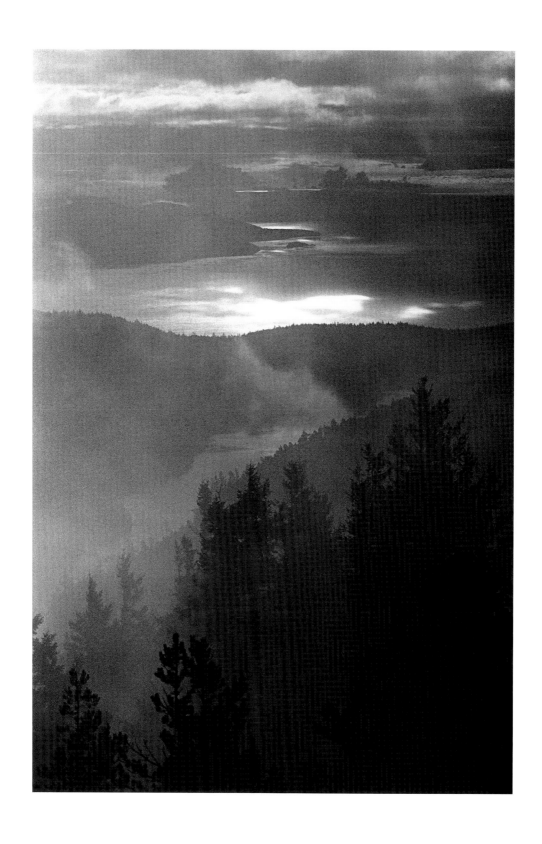

76 / MOUNT CONSTITUTION, DECEMBER 1993

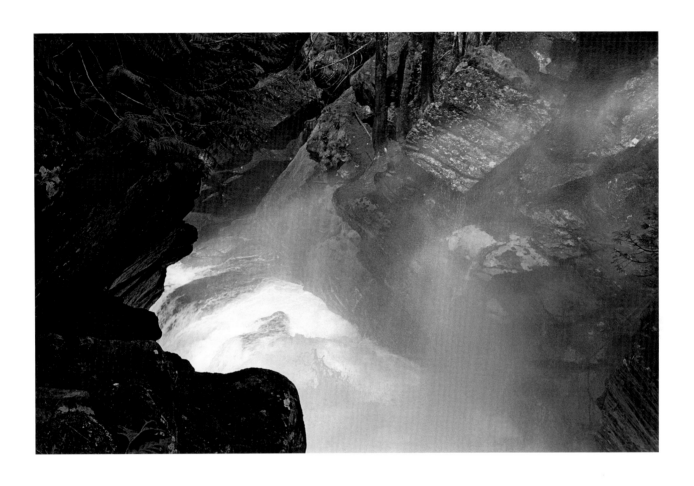

77 / WHITE RIVER FALLS, AUGUST 2001

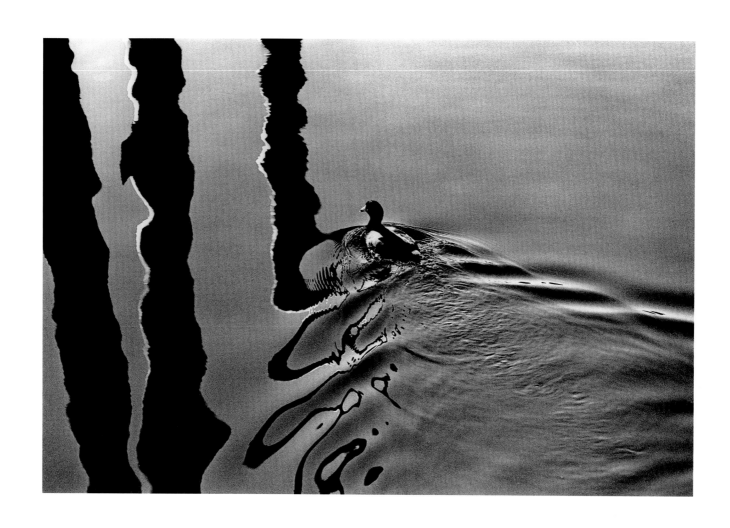

78 / COOT, NOVEMBER 1967

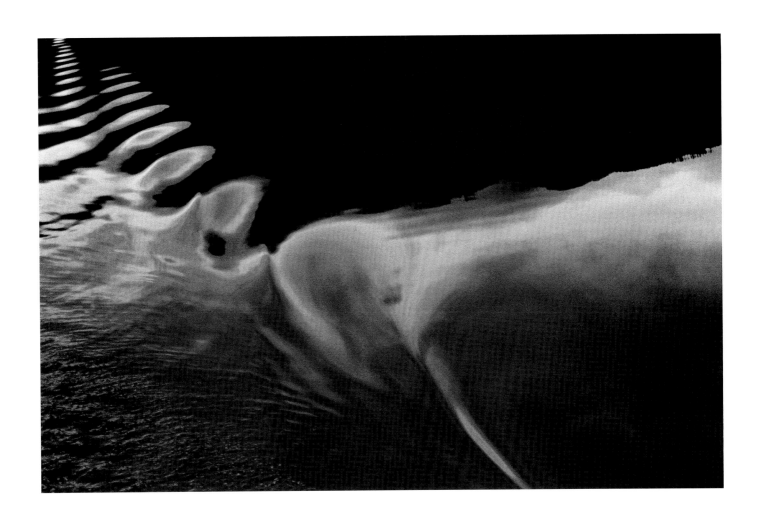

79 / WAKE OF THE *SNOW GOOSE*, JULY 1996

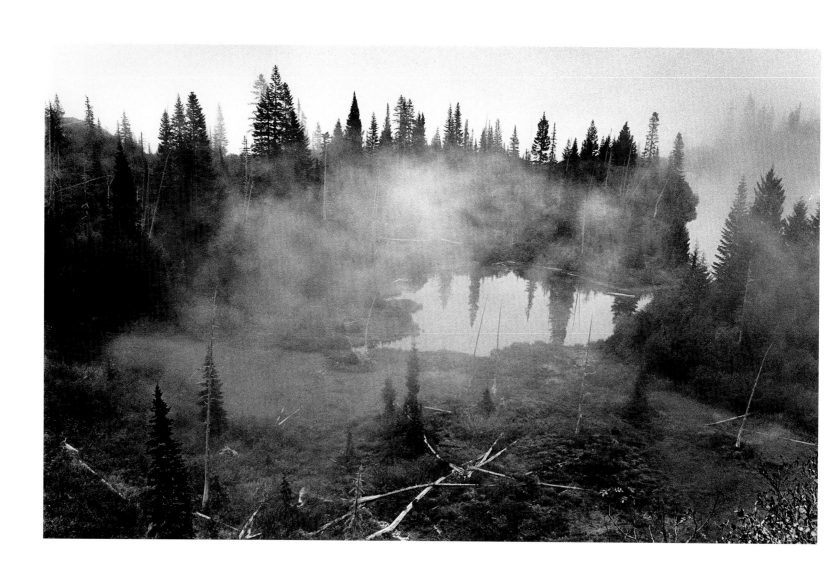

80 / BENCH LAKE, OCTOBER 1994

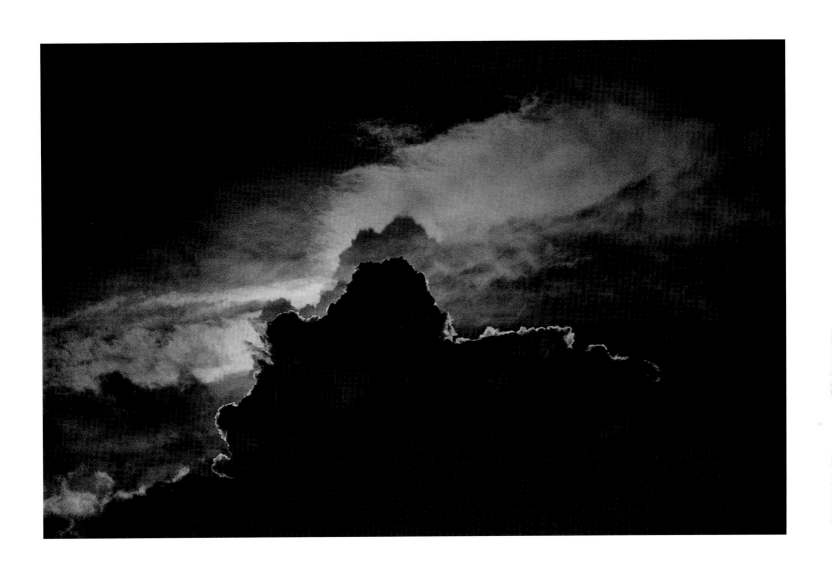

81 / CLOUD LANDSCAPE, NOVEMBER 1998

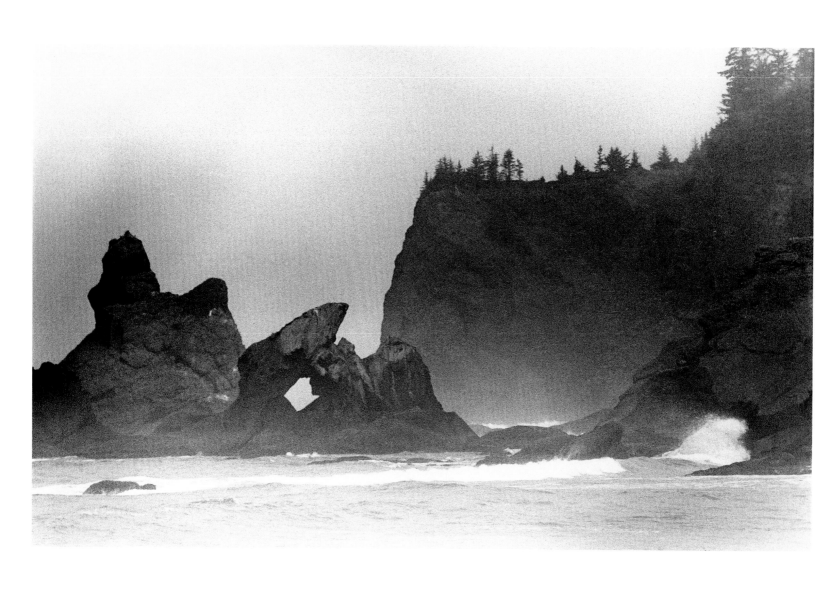

82 / SHI SHI BEACH, AUGUST 1986

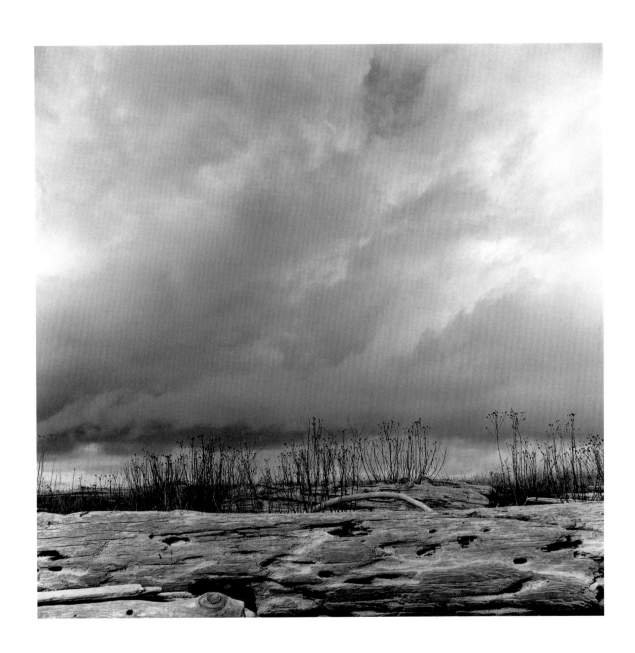

83 / SANDSPIT, STRAIT OF JUAN DE FUCA, APRIL 1981

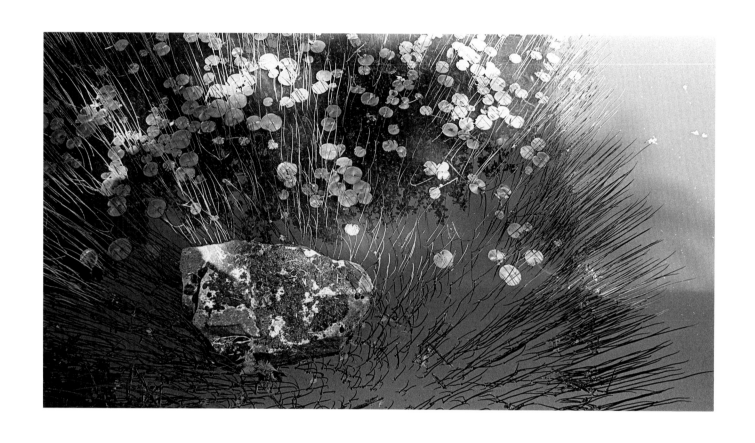

84 / POND IN MORRIS GRAVES'S GARDEN, MAY 1979

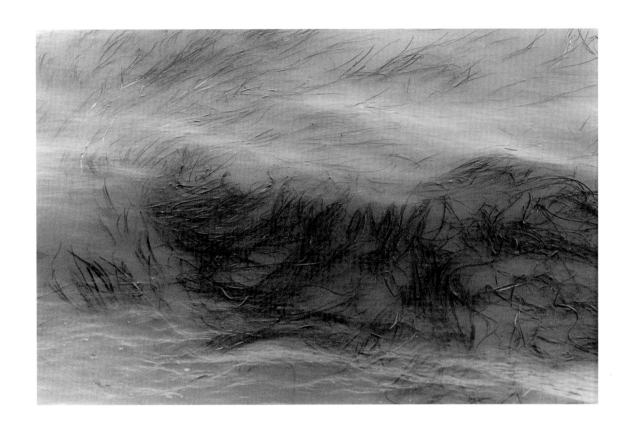

85 / SEAWEED AT LOW TIDE, AGATE POINT BEACH, JUNE 1986

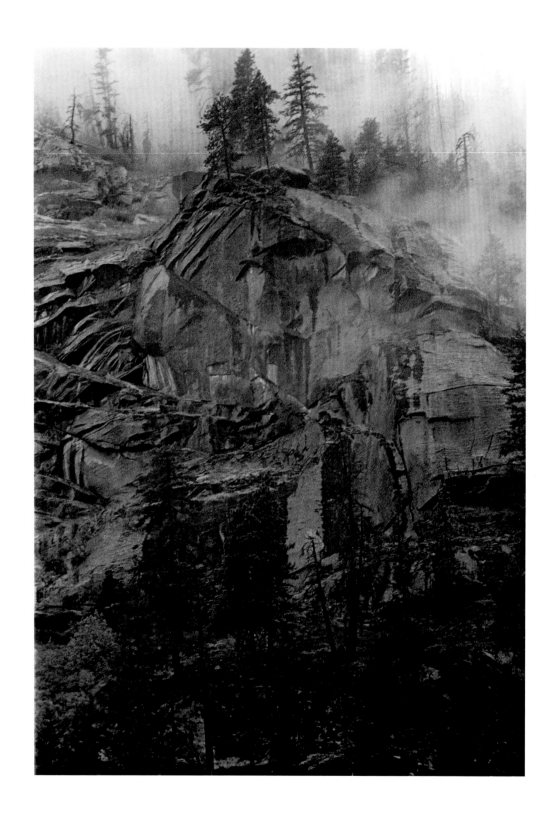

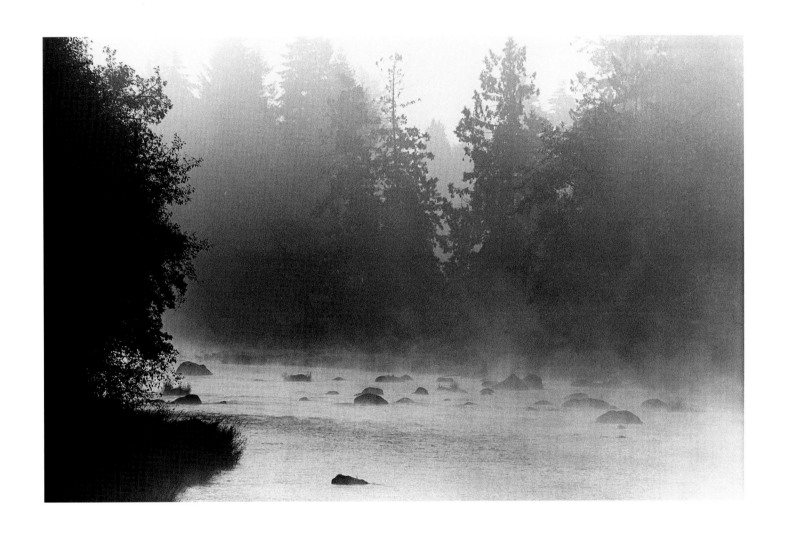

87 / NISQUALLY RIVER AT MCKENNA, OCTOBER 1990

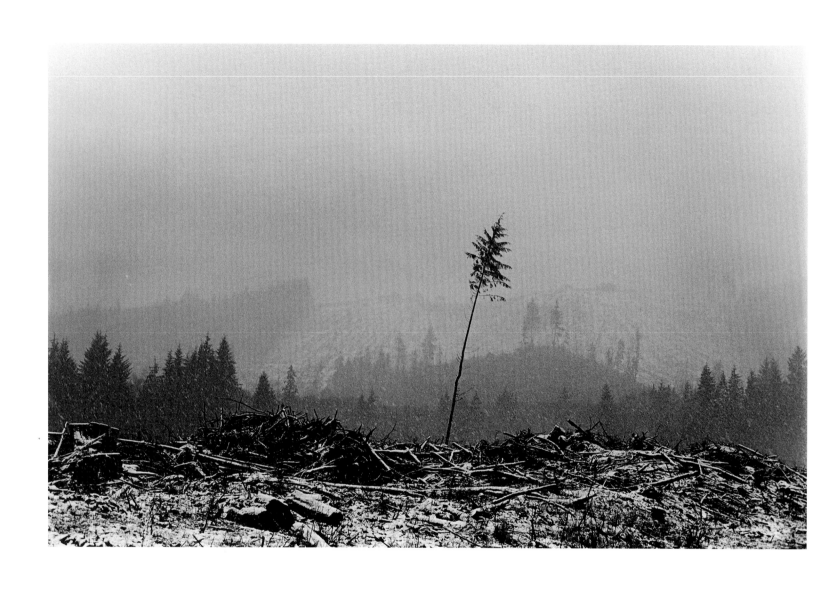

88 / COASTAL CLEARCUT, JANUARY 2002

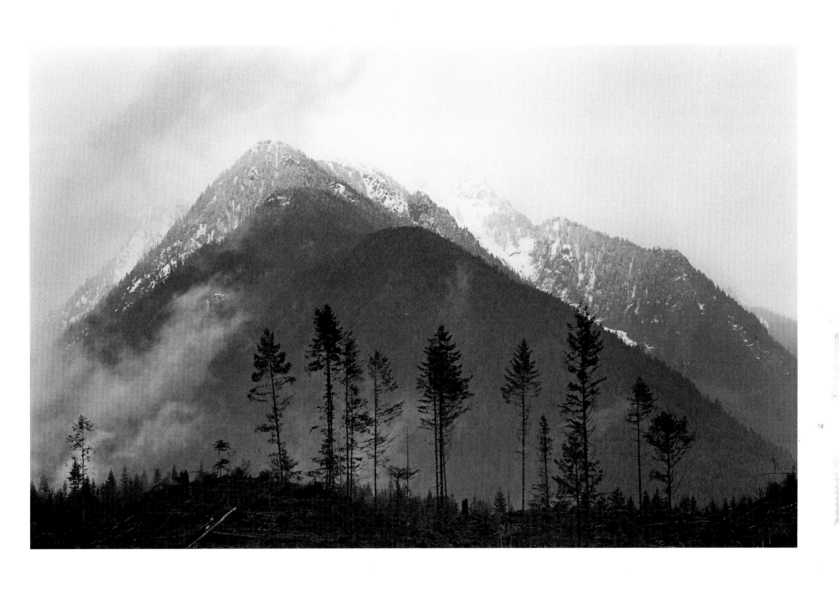

89 / DARRINGTON AREA, FEBRUARY 1992

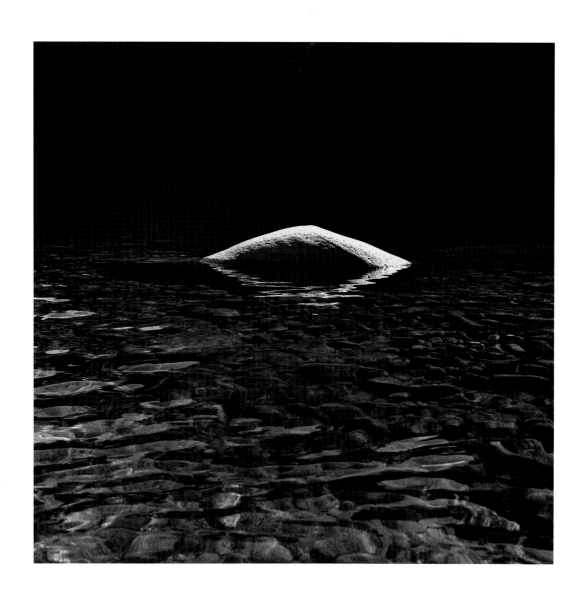

90 / RIVER ROCK, SKYKOMISH RIVER, SEPTEMBER 1967

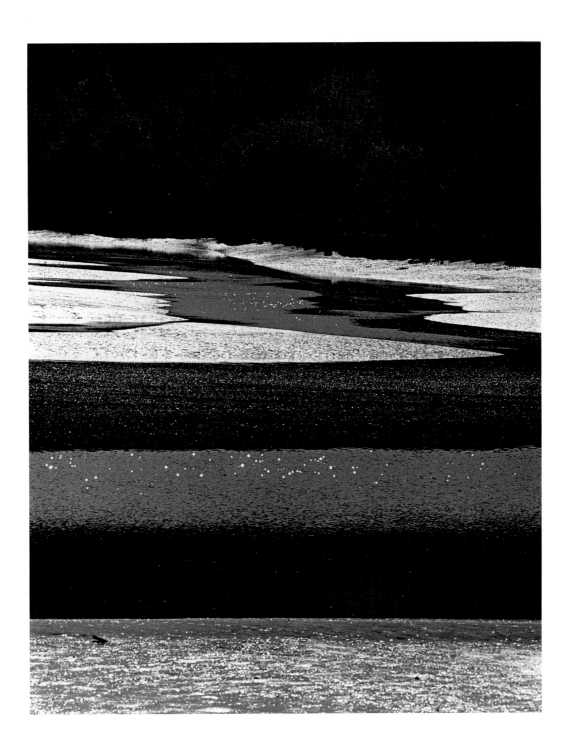

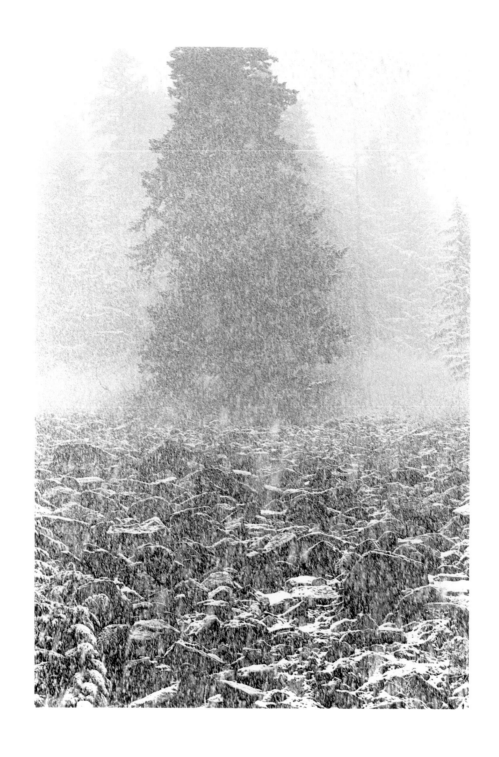

92 / TREE AND ROCK FORMS IN FALLING SNOW, MARCH 2001

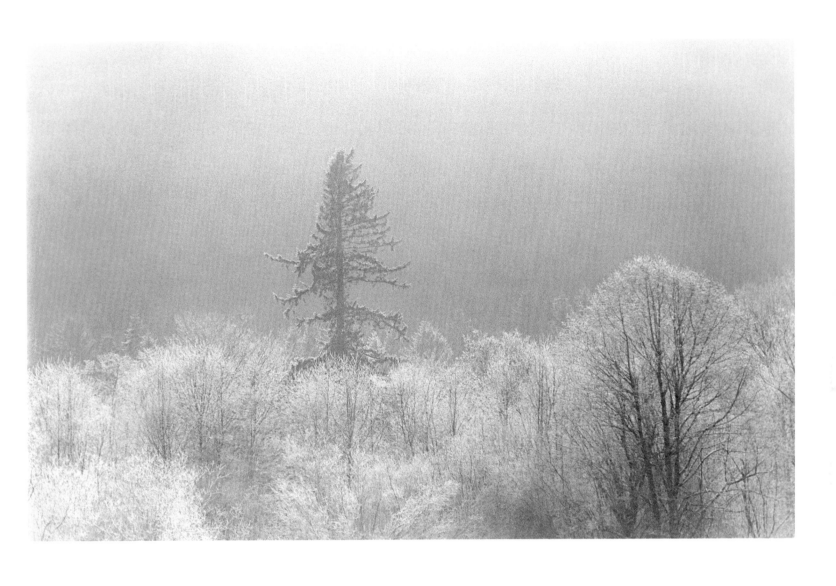

93 / HEAVY FROST, NOVEMBER 2006

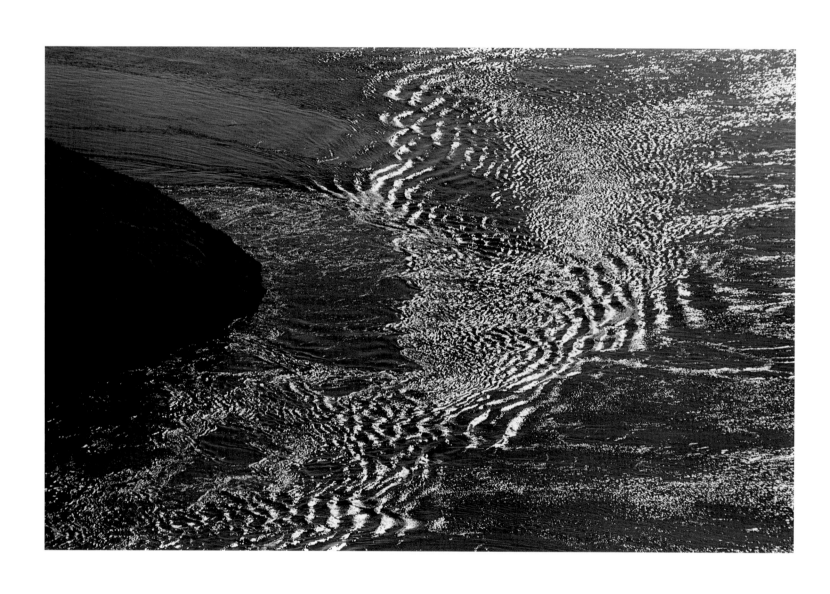

94 / DECEPTION PASS 3, JULY 2002

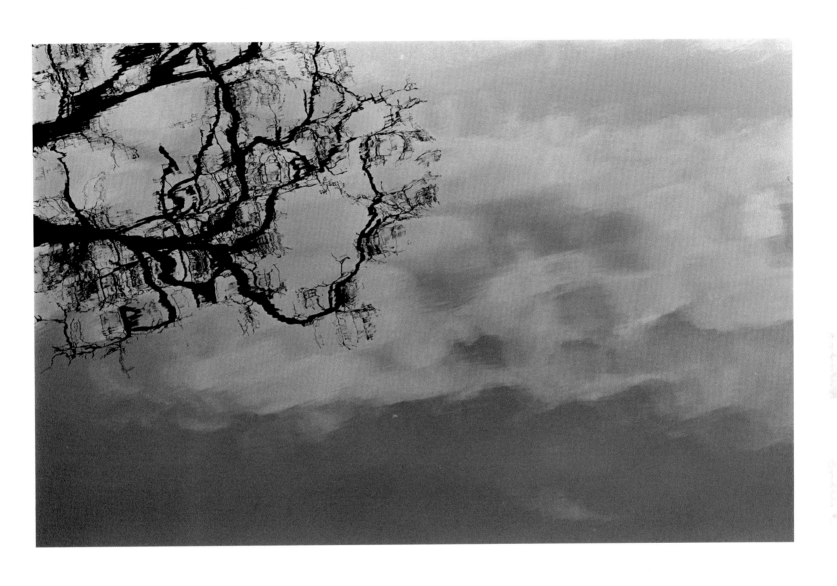

95 / TREE AND CLOUDS REFLECTED ON WATER, DECEMBER 2006

Afterword

JOYCE THOMPSON

"MY NATURE PICTURES," MARY CALLS THEM. IT IS A DECEP-
tively mundane name for an astonishing body of work. For most of her forty
years as a professional photographer, Mary Randlett has diligently photo-
graphed Northwest artists, families, works of art, and buildings—anything
editors or other clients paid to put before her lens. In the course of making a living, Mary created
an important visual archive of a people, a culture, and a time. But the photographs that matter
most, the ones that make manifest her lifetime's love affair with the light, the weather, the waters,
and the landforms of the Pacific Northwest, were—as her seventieth birthday approached—known
mostly to her friends. While early masterpieces like "Ryder's Light" and a few others had been
exhibited and reproduced, literally hundreds more, fixed on film over the space of a decade or
more, had not yet been cropped or printed. It was an absurdity, almost as if Wallace Stevens had
achieved the foyer of his eighth decade known only as a damn good insurance salesman.

Mary Randlett has a talent for friendship nearly as prodigious as her artist's gifts. Her sev-
entieth birthday was approaching, and it took me only a few phone calls to recruit cohosts for a
celebration-cum-exhibition. Gordon Woodside and John Braseth graciously offered the use of their
gallery. Dorothy Anthony, Florita Skov, Vel Gerth, Peggy Enderlein, Skippy Younger, Barb Bay-
ley, Susan Busch, and Tanya De Marsh, all promised food, drink, and labor. Ted D'Arms became
our toastmaster. Virginia Hand designed the invitation; Merch Pease had it printed and mailed. It
expressly requested that, instead of flowers, Mary's friends honor her birthday with gifts of money,
a grassroots grant intended to make it possible for her to print the nature pictures then still on
contact sheets, and from them to select the best for publication as a book.

On the evening of May 5, 1994, Mary's nature pictures hung in neighborly array with can-

vases by Morris Graves and Kenneth Callahan, a proximity that made clear just how painterly her vision is. The weather was fine that evening, and we had plenty of refreshments to serve the seventy-five or so people we hoped would turn up. Resplendent in a new outfit of pink and purple, Mary was jittery. What if nobody came?

She needn't have worried. From the moment the gallery door opened until we swept the floor and headed home, friends and admirers poured through—a rough guess puts the number well over three hundred. While friends, family, and fellow artists toasted Mary and shared anecdotes, we of the "committee" took up impromptu collections among ourselves and shuttled back and forth to the nearest grocery to buy more and more wine. Past midnight, back at Mary's house on Bainbridge Island, she and I opened the birthday cards that had filled the gift-wrapped cardboard box in the center of the gallery. Wonderful expressions of love and confidence poured out. So too did nearly six thousand dollars. Mary and I laughed and laughed, from the very bottom of our souls.

Denise Levertov unavoidably missed Mary's birthday in 1994, as she will whatever celebration attends the publication of this book, yet her spirit attends on both occasions. Back then she was in the middle of a long-planned visit to her native England, but her generous check launched the Mary Randlett Fund. It is easy to imagine her now, in earnest pursuit of her soul's next assignment, pleased to observe from whatever distance the fruition of a friendship that came late, demanded accommodation, yet was of real importance to both women.

Mary was born gregarious. Denise needed shelter in solitude's deep shadows. Even at seventy-five, Mary can shoot pictures and hobnob with people all day long, work in her darkroom until well past midnight, and be up at six the next morning to start again. Denise found dreaming necessary and sleep seductive; at least in the late years that Mary and I knew her, she slipped into her day instead of leaping, and one wouldn't dream of calling her before 10 a.m. Mary is almost indiscriminately approving of her fellow artists, whatever their medium or the breadth of their gifts. Denise was blessed, or cursed, with a stern aesthetic that demanded judgments to be made. Both women were, are, compassionate and generous to a fault, yet one wonders if those virtues flowed from the same spring. In Mary, they appear to be a gift of nature; in Denise, I suspect they were the achievement of a penitential will. In either case, those touched by them felt nurtured, and sanctified.

Their commonalities are as striking as their differences. Fine music sustained and transported them. The necessity of making art, the sheer fascination of living armed each woman in her battles with disease. Do you know two women who reached seventy looking better? Denise with her

fine English skin, Mary with her year-round tan and outdoor glow, each with her distinct style, her surprising coquetteries. Mary and Denise shared not just artistic depth and discipline but a wonderful vanity as self-amused as it was real. To hear them compare face creams and grooming tips was like being privy to the secret speech of angels. In the short space between meeting and parting, they were able to share a few memorable roadtrips, a few great concerts, and a few good friends.

At bottom, though, art called to art, and gift acknowledged gift. Having met, both women understood that they had some special business to transact.

This book bears witness to what they did.

Friends of Mary Randlett

Dennis Andersen · Mary K. Anderson · David and Dorothy Anthony · Thomas Aslin · Patricia Baillargeon · Emery and Lilly May Bayley · Frances Stimson Bayley · Barbara Berger · Ann Bernstein and Harold Chesnin · William and Beatrice Booth · Catherine Brownell · Stimson Bullitt · Earl Cahail · Kim Chaloupka · J. Prichard Cohen · Dorothy Conway · Ted D'Arms· Tanya De Marsh · Wayne Dodge · Patrick and Susan Dunn · Don Ellegood · Christoph and Mary Enderlein · Alexander and Elizabeth Fisken · Albert and Irene Fisher · Ann and Donald Frothingham · Vel and Bob Gerth · Richard Gilkey · Nikolai Goodman· Colin Graham · Richard Haag · Virginia Hand · LaMar Harrington · Anne Gould Hauberg · Mary Heffernan · Barry Herem · Dave and L. Hotaling · John and Barbara Huston · Janet Huston · Clayton and Barbara James · Tom Jay · Josephine Jenner · Russell Johanson · Erik and Jeanette Jorgensen · Hans and Elaine Jorgensen · Julia and François Kissel · Frank and Virginia Kitchell · Henry Klein · Kathleen Kler and David Haakenson · Lawrence Kreisman · Jean Lawler · William and Elizabeth Lawrence · Br. Boniface V. Lazzari · Denise Levertov · Ken and Betty Lewis · Shirley Ludwig · Philip and Anne McCracken · Bill and Dale Mills · Murray and Rosa Morgan · Ann Morris · Billie Noe · Kathleen O'Neill and Thomas Leschine · Frank and Harriet Pattison · Alice Pease · Cornelius and Gloria Peck · Nat and Dorothy Penrose · Andrew and Marianna Price · Freda Quenneville · J. Richardson · Margaret Riddle · Jo Ann Ridley · Beth Sellars · Pat Soden and Marilyn Trueblood · Leroy and Joie Soper · Ervin and Floria Skov · Michael and Elizabeth Spafford · Jeffree Stewart · Rachel Straley · Leo and W. M. Trask · Jerry Traunfeld · University of Washington Press staff · Edward and Patricia Van Mason · Dederick Ward and Susan Parke · Christine White · Paul and Mary White · Donald and Gail Willis · J. Karyl Winn · Barbara Winther · Charles and Virginia Wright · Erin Younger and Edward Liebow · Virginia Younger

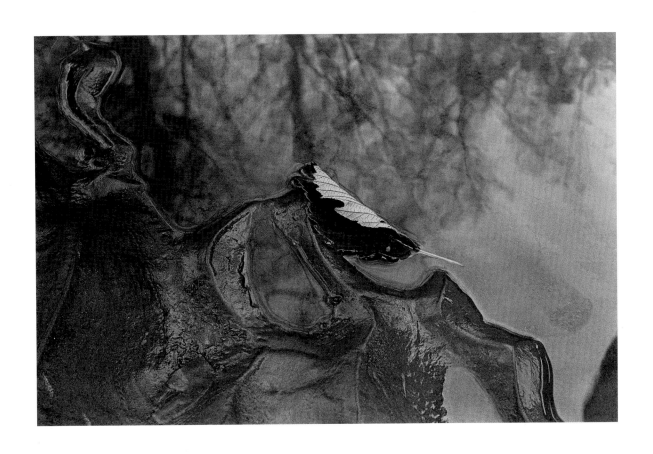

99 / AUTUMN REFLECTIONS, OCTOBER 1966

Chronology

COMPILED BY JO ANN RIDLEY

The exhibitions, portraiture, publications and honors included in this chronology are selected from an extensive list of achievements during six decades of the artist's work. Museum, archival, and private collections have been omitted.

1924
Born May 5 in Seattle, Washington, first of four daughters of Cecil D. Willis and Elizabeth Bayley Willis, descendants of two prominent Seattle families.

A lifelong love affair with nature is nurtured from infancy by summers spent on the beaches and waters of Puget Sound and the San Juan Islands, winters skiing in the Cascade mountains, and hunting trips with father and grandfather, Dr. Park Weed Willis, in the Skagit Valley and Eastern Washington.

1926–1933
Lives on Queen Anne Hill, Seattle, attends private kindergarten and West Queen Anne Grade School.

1933
Family moves to Bainbridge Island in Puget Sound near Seattle, where woods and shoreline playgrounds dominate childhood experiences.

1935
Given first camera by her father. At age eleven produces first album of photographs, taken in the San Juans.

1935–1938
Family returns to Seattle, residence near the Seattle Art Museum, where attendance at Saturday lectures for young people instills appreciation for art an early age.

1938
Parents divorce; mother and daughters live with maternal grandparents. Enters Queen Anne High School

but chafes in confinement of classrooms, longs to be out of doors. Acquires a folding Eastman Kodak camera that shoots 620 film, begins to take pictures with serious purpose, concentrating on boats and Puget Sound during island summers.

1939

Enrolls in photography classes but withdraws after one or two sessions because she wants to learn darkroom techniques, not to be told how to take pictures.

Randlett's mother, undertaking own successful international career in the arts, develops important relationships with artists, writers, photographers, and galleries that later will provide unique entree for her daughter.

1943

Admitted to Whitman College, liberal arts school in Walla Walla, Washington, without having graduated from high school, earns B.A. degree in political science.

1944

Discovers a darkroom in college science hall, develops and prints photographs of students and faculty, campus buildings. Experiments with infrared film; works also with a Kodak Bantam 35 mm camera. Wins her first prize for photography.

1947–1950

Following college graduation lives with grandparents north of Seattle. Wants only to be a photographer. Seeking a professional with whom she can apprentice, meets Hans Jorgensen, former assistant to fashion photographer Louise Dahl-Wolfe, now working in Seattle. Accepts his offer of an apprenticeship without pay.

Jorgensen introduces her to twin lens Rolleiflex camera. "The whole world opened up and my career in photography began." Borrows $325 to buy a Rolleiflex and begins to take family and children's portraits professionally. Jorgensen offers good advice and tools to learn printing and darkroom work, but never how to take a picture or crop a photo.

Informal portraits by George Mantor, only photographer ever to directly influence her work, enlarges her vision of portraiture beyond traditional snapshots and studio sittings.

Becomes busy with portraiture and other work, leaves Jorgensen's studio.

1949

Photographs Morris Graves, painter, beginning a significant portfolio of dozens of artists and writers.

Commissioned by boat builder Anchor Jensen, photographs racing boat *Slo-Mo-Shun IV* on speed-record-breaking maiden voyage at 150 mph, photos published nationwide by Associated Press.

1950

Buys but soon sells first of several view cameras, always rejected as "not for me."

Photographs writer Henry Miller, Big Sur, California.

Meets photographer Imogen Cunningham, who becomes an encouraging admirer.

Marries college friend Herbert Randlett, an accountant, in Palo Alto, California. They have four children within six years: Robert, 1951; Mary Ann, 1953; Peter, 1955; Susan, 1957.

1951–1972

Randletts buy Bayley grandparents' former home in Woodway Park, Washington; she continues professional portrait work but gradually is drawn to nature photography.

1963

Photographs poet Theodore Roethke at his request, two weeks before his death.

1964

Begins long relationship with University of Washington Press when her images of Roethke appear in the Press's first book about the poet.

Approaches five prominent Northwest artists—William Cumming, Guy Anderson, Viola and Ambrose Patterson and Kenneth Callahan—and asks to photograph them in their homes and studios. All consent.

1965

First exhibitions: The Drawing Room, Edmonds, Washington; Bainbridge Island Arts and Crafts, a cross section of her work with nature, children, and artists.

Extending horizons beyond portraiture and nature photographs, begins to photograph Seattle architecture; work published in newspapers, magazines, and books across the country.

Photographs Imogen Cunningham.

1966

Photographs Carolyn Kizer, future Pulitzer Prize–winning poet.

1967

Photographs appear in important Seattle Arts Commission Report.

Acquires new through-the-lens Rolleiflex SL66, to photograph AIA project *Action: Better City* at behest of prominent Seattle artists' mentor Betty Bowen. This instigates long association with Seattle architects Ralph Anderson, Al Bumgardner, Ibsen Nelson, Victor Steinbrueck, and Fred Bassetti.

Abstract patterns and textures emerge in nature photos, inspired by "eye opening" paintings of Northwest artists she is photographing.

New Pentax Spotmatic camera with telephoto and wide angle lenses captures sandpipers in flight at Long Beach, Washington, encourages new nature projects.

Photographs novelist Tom Robbins.

1968

Relating intensely to mountain paintings of Kenneth Callahan and Neil Meitzler, begins to photograph in the Cascade Mountains. After photographing Northwest artist Leo Kenney, begins series of "circles of water" images.

1969

First Seattle exhibition: Richard White Gallery.

Commissioned to photograph abandoned Seattle gas works, soon to be converted to a park by landscape architect Richard Haag. Randlett documents the stunning massed forms of the gas works buildings and equipment from different parts of Lake Union.

1970

Documents fabrication of Isamu Noguchi's sky viewing sculpture, Lynnwood, Washington, and installation at Western Washington University, Bellingham, Washington.

With Ford Foundation grant, administered by Susan Olsen, photographs Northwest Native American (Lummi) master carvers Al Charles, Morrie Alexander and their apprentices, and Whatcom Museum restoration.

Exhibition: Whatcom Museum of History and Art, Bellingham, Washington.

Participates in group exhibitions: *Infinity 70, 25th Anniversary Exhibit,* American Society of Magazine Photographers, New York, New York; *"Skyviewing Sculpture of Isamu Noguchi,"* Cordier and Ekstrom Gallery, New York, New York.

1971

Divorced; continues to photograph artists in Washington, Oregon, and British Columbia.

Exhibition: *Artists of the Pacific Northwest,* Seattle Art Museum Pavilion.

Photographs Jacob Lawrence, painter.

1972

Exhibitions: Greater Art Gallery of Victoria, Victoria, British Columbia; Focus Gallery, San Francisco, California; Western Association of Art Museums, Calgary, Ontario.

1972–1976

Accompanies Susan Olsen to East Coast, researches Native American art and artists of Northwest during travels to universities, museums, libraries, and national parks while Olsen conducts research for the Smithsonian's National Portrait Gallery.

National Park Service commissions photographs for the National Register of Historic Places, which appear in a 1976 two-volume publication.

Photographs appear in *Isamu Noguchi: The Life of a Sculptor*, Tobi Tobias, Crowell Publishers, New York; *America's Forgotten Architecture*, National Trust for Historic Preservation, Preservation Press, Washington, D.C.

1977–1978

Returns to Pacific Northwest, resumes nature and portrait photography, adds to artists portfolio.

Settles for the next twenty years into studio cottage on Elizabeth Bayley Willis's Bainbridge Island property.

Continues to fulfill commissions and assignments, work appears in art and architecture books and publications throughout United States.

Group exhibitions: *International Exhibit*, Royal Photographic Society, London, England; *Wood, Metal & Paper: Contemporary Works from the Northwest Coast*, The Heard Museum, Phoenix, Arizona.

1979

Images appear in *Contemporary American Poetry*, Al Poulin, Jr., Houghton Mifflin & Co., Boston.

1980

Listed in *Who's Who in American Art*.

Photographs appear in *This Song Remembers: Self-Portraits of Native Americans in the Arts*, Jane Katz, E. P. Dutton Company, New York.

1981

Listed in *Who's Who in American Women*.

1982

Photograph appears in *George Tsutakawa*, History and Folk Museum, Sendai, Japan.

Photographs Jack Lenor Larsen, fabric designer.

1983

First photographer to receive Washington State Governor's Award of Special Commendation for "unique contributions to the field of photography," and accompanying exhibit, *Mary Randlett: A Selection from 35 Years* at the State Capital Museum, Olympia, Washington.

Group exhibition: *Three Northwest Photographers*, Seattle Pacific University, Seattle.

Photographs appear in *Sketchbook: A Memoir of the 30's and the Northwest School* by William Cumming, University of Washington Press.

1984

Photographs appear in *Mark Tobey: City Paintings*, Eliza Rathbone, National Gallery of Art, Washington, D.C.

Photographs Northwest Native American artist James Schoppert, Tlingit.

1986

Takes another step into "the mysterious world of light and photography" with seminal image *River Rock in Shadowed Sunlight* at Mount Rainier National Park. First literal use of sunlight; she is changing her way of looking at light on the landscape.

1987

Group exhibition: *The Small Show*, Santa Fe Center for Photography, Santa Fe, New Mexico.

1988

Assigned to create the essence of nature in photographs of the Bloedel Reserve on Bainbridge Island; resulting work reflects a singular devotion to the use of sunlight in nature photography.

Images appear in *The Bloedel Reserve: Gardens in the Forest*, Lawrence Kreisman, Arbor Fund, Seattle.

Group exhibitions: *Jacob Lawrence, The Washington Years*, Tacoma Art Museum, Tacoma, Washington; *Voices of the Raven*, Helen Day Art Center, Stowe, Vermont.

1989

Meets poet Denise Levertov; a deep mutual admiration for each others' work leads to lively artistic collaborations until Levertov's death in 1997.

Exhibition: *Mary Randlett: Photographs of Twelve Northwest Artists*, Janet Huston Gallery, La Conner, Washington.

Photographic essay appears in *Openings: Original Essays by Contemporary Soviet and American Writers*, Robert Atwan and Valeri Vinokurov, eds., University of Washington Press.

1991

Group exhibition: *Northwest Portfolio*, Governor's Gallery, Office of the Governor, Olympia, Washington.

Photographs appear in *Natural History of Puget Sound Country*, Arthur Kruckeberg, University of Washington Press.

1992

Collaborates with author James Rupp on *Art in Seattle's Public Places*, University of Washington Press.

Exhibition: *Mary Randlett: Photographs*, Stonington Gallery, Seattle.

Photographs Joyce Thompson, fiction writer.

1993

Listed in *Who's Who in America.*

1994

Friends honor Randlett's 70th birthday with party at Woodside Braseth Gallery, Seattle.

Group exhibition: *Cast at River Dog*, Port Angeles Fine Arts Center, Port Angeles, Washington.

Photographs for *Seeing Seattle*, guidebook by Roger Sale, University of Washington Press.

1996

Group exhibitions: *Seattle Comes to Christ Church*, Christ Church, New Zealand; *Present and Future: Architecture in Cities (Barcelona '96)*, XIX Congress of the International Union of Architects, Barcelona, Spain.

1997

Moves to Olympia, Washington.

Exhibition: *Inside Backcover, Literary Portraits of Mary Randlett*, Tacoma Public Library.

Photographs appear in *The Bloedel Reserve and Gas Works Park — Richard Haag*, Princeton University Press, Princeton, New Jersey.

Randlett's photographs of Guemes Island inspires Levertov poem that bases the first movement of *The Sound of Light*, a new symphony by Robert Kyr, commissioned by the Oregon Humanities Center. Premiered in Portland by the Oregon Symphony.

1998

Exhibitions: *The Light and the Landscape: Photography of Mary Randlett*, Henderson House Museum, Tumwater, Washington; *Portraits of Writers: Mary Randlett*, Northwest Book Fest, Seattle; *In Love with Light: Mary Randlett Photographs*, Museum of Northwest Art, La Conner, Washington.

1999

Reflections: Skagit River selected as cover art for *This Great Unknowing: Last Poems*, Denise Levertov, New Directions, New York.

Group exhibitions: *The View from Here: 100 Artists Mark the Centennial of Mount Rainier National Park*, Selected Works, Shimin Bunka Kaikan/Citizen's Cultural Center, Fujinomiya, Japan; *Instruments of Change*, James Schoppert retrospective, Smithsonian National Museum of the American Indian, New York.

2000

Solo exhibition: *In Celebration of Art Day*, Washington State Capital Museum, Olympia.

Group exhibitions: *Tumwater Then and Now: Boom Years to Prohibition*, Henderson House, Tumwater, Washington; *Paul Horiuchi*, Seattle Asian Arts Museum; *Olympia Through Artists' Eyes*, State

Capital Museum; *Leo Kenney: Celebrating the Mysteries, a Retrospective*, Museum of Northwest Art, La Conner, Washington; *Northwest Natural: Mary Randlett, Neil Meitzler, Eric Sandgren*, Lucia Douglas Gallery, Bellingham, Washington; *Land/Scape Photography: Mary Randlett–Ken Slusher*, Tacoma Public Library, Tacoma, Washington; *Morris Graves: Journey*, Museum of Northwest Art, La Conner, Washington.

Photographs appear in *Seattle Poets and Photographers: Millennium Reflection*, edited by Rod Slemmons and J. T. Stewart, Seattle Arts Commission, University of Washington Press; *The Complete Jacob Lawrence*, Peter Nesbett and Michelle DuBois, Seattle: University of Washington Press; *Isamu Noguchi: A Study in Space*, Ana Maria Torres, New York: Monicelli Press.

2001

Receives coveted Nancy Blankenship Pryor Award at Governor's Writers Award ceremony, Washington State Library, Olympia, Washington.

Receives Artist Trust Lifetime Achievement Award, Seattle, Washington.

Career materials installed in Archives of Women Artists, Library and Research Center, National Museum of Women in the Arts, Washington, D.C.

Photographs of twenty-one artists illustrate *Iridescent Light: The Emergence of Northwest Art*, Deloris Tarzan Ament, Seattle: University of Washington Press.

Photograph selected as cover art for *The Bloomsbury Review: A Life of Poetry*, Sam Hamill, Denver, Colorado.

2002

Awarded honorary membership in the American Institute of Architects in Seattle, Washington.

Solo exhibition: Mary Randlett: Portraits in the Arts Community, Wright Exhibition Space, Seattle.

Group exhibitions: Over the Line: The Art and Life of Jacob Lawrence, Detroit Institute of Art, Detroit, Michigan; High Museum, Atlanta, Georgia; Seattle Art Museum, Seattle, Washington.

Photographs appear in *Sounds of the Inner Eye: John Cage, Mark Tobey, Morris Graves*, ed. Wulf Herzogenroth and Andreas Kreul, English ed. published by University of Washington Press and the Museum of Glass, Tacoma, Washington.

Participates in and photographs artists for Images of the Watershed, Leavenworth, Washington.

2003

University of Washington Suzallo Library Special Collections acquires negatives and prints of Randlett's life work.

Honored as a History Maker in the Arts by Museum of History and Industry, Seattle, Washington.

Receives Alumnus of Merit Award, Whitman College, Walla Walla, Washington.

Subject of television documentary, *Mary Randlett*, produced by Sheila Mullen, Seattle Community College.

Solo exhibition, Mary Randlett and the Creative Neighborhood, Safeco Plaza, Seattle and Redmond, Washington.

Group exhibition: New Acquisitions for the Collection, Tacoma Art Museum, Tacoma, Washington.

Photographs appear in *Northwest Mythologies: The Interactions of Mark Tobey, Morris Graves, Kenneth Callahan, and Guy Anderson*, Sheryl Conkelton and Laura Landau, Seattle: University of Washington Press.

2004

Solo exhibitions: Northwest Masters Selection from City of Seattle's One Percent for Art, City Space, Seattle.

Group exhibition: Philip McCracken, 600 Moons, Museum of Northwest Art, La Conner, Washington.

Photographs appear in *600 Moons: 50 Years of Philip McCracken's Art*, Deloris Tarzan Ament, Seattle: University of Washington Press.

Photographs selected as cover art for *The Accidental Collector: Art, Fossils, and Friendships*, Wesley Wehr, Seattle: University of Washington Press; *Passing the Three Gates: Interviews with Charles Johnson*, ed. Jim McWilliams, Seattle: University of Washington Press.

2005

Exhibition: Mary Randlett Nature Photographs, with Ann Morris, Bone Journey II, Lucia Douglas Gallery, Bellingham, Washington.

Photographs appear in *Groundswell: Constructing the Contemporary Landscape*, Museum of Modern Art, New York; *Pacific Voices: Keeping Our Cultures Alive*, Miriam Kahn and Erin Younger, Seattle: University of Washington Press.

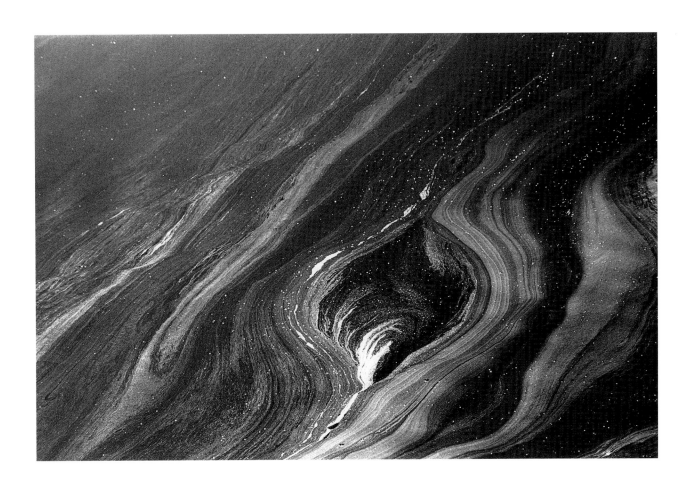

109 / WATER FORMS, JANUARY 1994

Acknowledgments

MY SENSE OF BEAUTY—AND THE DREAM IT INHABITS—HAS been sustained throughout my life by the friendships of the artists, writers, and friends I have known. Their help and support and the help and support of my family enhance and encourage everything that I do.

First, my gratitude to the late Denise Levertov, who enriched my life through her kindness and friendship and through her gift of the poems and essay for this book. I miss her. These seven poems first appeared in *Sands of the Well* (New Directions, 1996) and were written for the photographs they accompany. My thanks to Barbara Epler, editor-in-chief at New Directions, and to Paul Lacey and Valerie Trueblood, co-trustees of the Denise Levertov Literary Trust. Thanks also go to Denise Levertov's son, Nikolai Goodman, who has waited a long time for this book; and to Marleen Muller, Denise's last assistant and a generous source of help to me.

This book had its beginnings in the efforts of three friends: Ted D'Arms, a renaissance man whose talents encompass all of art and who has consistently supported what I do and writes about it lyrically and with rare understanding; poet Denise Levertov; and writer Joyce Thompson. Later, the addition of Barry Herem's wonderful essay brought the book into crisper focus.

My photograph "Reflections: Skagit River" appears on the jacket of Denise's Levertov's last book of poems *This Great Unknowing* (New Directions, 1999), in the same spirit that her writing now appears here—as a gift of understanding. The great rivers of the Northwest, the Olympic and Cascade Ranges, the ocean's beaches, and the wheatlands of Washington's eastern interior have inspired these photographs. Many friends have stood beside me in these places, each giving me a fresh eye to record the essence of the landscapes. To stand with Roderick Haig-Brown on the Camp-

bell River in 1965 was to have the river opened up before my eyes. Over the years, artists and writers have given me the vision to experience subtle nuances in the world surrounding me, among them Morris Graves, Mark Tobey, Guy Anderson, Richard Gilkey, Bill Cumming, William Ivey, Philip McCracken, Leo Kenney, Clayton James, and Donald Frothingham. The mysterious, delicate energy in George Tsutakawa's fountains and the magnificence of our beautiful, rugged mountains transformed into the paintings of Neil Meitzler and Kenneth Callahan are a gift. From Robert Sund's elegies to the wheat country of eastern Washington and sloughs of the Skagit Valley, to the poems Theodore Roethke created while wandering along the paths on Bainbridge Island that I had also walked since childhood, to the rivers and woods I thought I knew so well in David Wagoner's work—each opened another world for me to find in photographs. The writing and sculpture of Tom Jay and Tony Angell and the work of so many others encouraged me to study anthropology, botany, architecture, geology, and so much more.

Hans Jorgensen, former assistant to the American photographer Louise Dahl-Wolfe in New York, introduced me to the world of photography and to my first twin-lens Rolleiflex in 1948. My apprenticeship with Hans was the beginning of a lifetime in photography I could never have imagined. Anchor Jensen, builder of the hydroplane *Slo-mo-shun IV*, built my first darkroom in a little shack on the Woodway Park property of my grandparents, Frank and Molly Bayley. That was in 1948. Their support and encouragement allowed me to keep a roof over my head in the early days, and each supported my photography from the beginning. My mother, Elizabeth Bayley Willis, introduced me to the work of the great artists of Seattle, San Francisco, and New York. Her intelligence, integrity, and compassion for the artists and their work filled my life. Her support remained unwavering and her tremendous courage still inspires me. My sisters, Betsy Lawrence, Petie Coleman, and Pam Price, along with husbands William Lawrence and Marty Coleman, have supported and encouraged my work. My son Robert Randlett designed and built the darkroom and archive at Agate Point, Bainbridge Island, where I lived for twenty years, and he continues to organize my collections. My son Peter Randlette and my friend David Haakenson designed and shaped my present home and darkroom in Olympia. Special thanks to Peter's partner, Ruth Hayes, to Lisa Randlette, and to my granddaughter Perrin Randlette, for their love, suggestions, and encouragement. Thanks to my daughters Ann Randlett DeMarsh and Susan Randlett Busch and to their husbands, Walter DeMarsh and Mark Busch, for their love and understanding, and special love to Alexa Strabuk. Thanks also to Tanya and Al Dodson, Virginia Hand, Kit O'Neill and Tom Leschine, and Gunther and Sigrid Vierthaler.

I would never have been able to sustain my career without the unquestioning enthusiasm and support of my dear, life-long friends Skippy Younger and Peggy Enderlein. Mr. and Mrs. Prentice Bloedel provided me with important early and on-going support to print and purchase equipment. Later, Virginia and Bagley Wright, Ann Morris, Nancy Nordhoff, and Lynn Hays provided generous support for special projects. The Wenatchee Watershed Project in 2001 gave me access to landscapes and internationally recognized artists I had not met before, and I thank organizers Gretchen Daiber, Cynthia Neely, Gretchen Rhode, and, especially, Harriet Bullitt. Even this late in my career, the world remains filled with opportunities.

Very special thanks to my attorney Merch Pease, to my dealers, David Martin and Dominic Zambito, and to former University of Washington Librarian Richard Engeman for bringing my photographic archives to the attention of the University of Washington Libraries Special Collections. My documentary photography—300,000 negatives and prints—was purchased in 2000. My thanks to Robert Randlett and Peter Randlette for their help, and to attorney Don Kunze for presently overseeing my legal affairs.

Seattle photographers Dick Busher, Paul Dorpat, Greg Gilbert, and, significantly, Hugh Stratford were always there at the other end of the phone to help solve business and technical problems. David Gohn and Scott Lange have framed my photographs, and Roland Bert Garner and Michael McCafferty have always hung them beautifully. Other important friends who have been an inseparable part of my journey include Delores Tarzan Ament, Peggy Anderson, Mark and Julie Callen, Katherine Cotnoir, Linda Gardner, Vel Gerth, Barbara James, Brother Boniface Lazzari, Steve Lindstrom, Anne McCracken, Obi Manteufel, Sheila Mullen, Sue Olsen, Susan Parke, Chuck Pennington, Palmer Petterson, Bill Rhoades, Erik Sandgren, Ikune Sawada, Alice and Dave Shorett, Jeffree Stewart, Kathryn Wang, Barbara and Grant Winther, Carla Wulfsburg, and Erin Younger.

I am grateful to my friends at the Tacoma Art Museum, especially Stephanie Stebich, director; Paula McArdle, curator of education; Rock Hushka, curator; and Patricia McDonnell, formerly curator at Tacoma and now director of the Ulrich Museum of Art, Wichita State University, Wichita, Kansas.

My association with the University of Washington Press in the course of producing photographs for some seventy-five books since 1964 has given me not only many admired colleagues in the artistic and business side of book publishing, but lasting friendships as well. The late director Donald Ellegood, along with Audrey Meyer, Naomi Pascal, and Dorothy Anthony were among my first friends at the Press. Over the years, UW Press staff members have further enriched my life, including Mary Anderson, Denise Clark, Nina McGuinness, Veronica Seyd, Marilyn Trueblood,

and Don Ellegood's successor, Pat Soden. Guada Castro makes just walking into the Press's Seattle office a pleasure.

My thanks to Gretchen Van Meter and Marlene Muller for their help with the Levertov files and to Richard Rapport and Valerie Trueblood for their generous support of the book. I also thank my friend of many years, Jo Ann Ridley, for her advice and for the chronology she created. I am especially grateful to Audrey Meyer for this beautiful book.

M.R.
Seattle, 2007

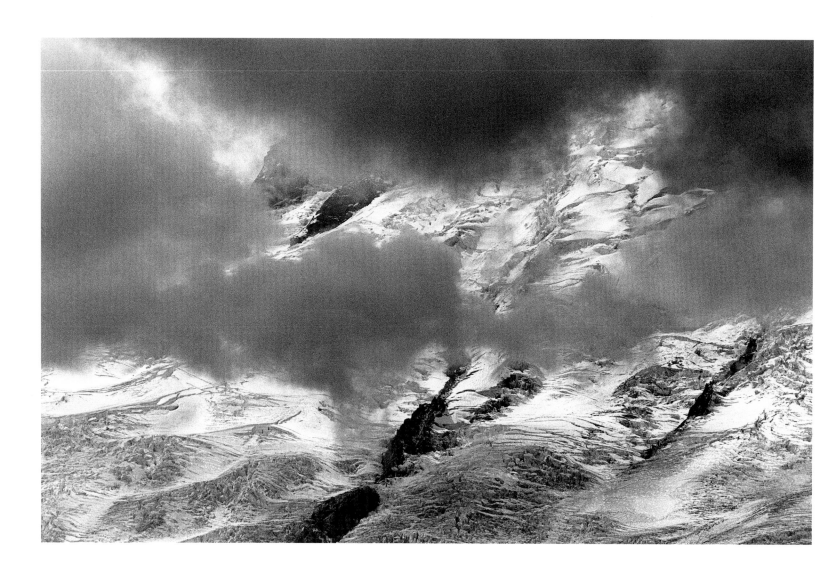

114 / ABOVE PARADISE, MOUNT RAINIER, SEPTEMBER 1992

Technical Notes

Cameras

1947–1968	Twin Lens Rolleiflex
1968–1978	2 pentax spotmatics 35mm
	2 Rollei SL 66 bodies
1978–2000	2 Nikon F bodies: 1 for black & white, 1 for color
2000–2006	3 Nikon F3 bodies: 2 for black & white, 1 for color

Lenses

For Pentax Spotmatics: 35 mm, 50 mm, 135 mm, 300 mm

For Nikon F3: zoom lens from 17 mm to 35 mm, 28 mm to 105 mm, 70 mm to 210 mm

 Other lenses from 20 mm to 300 mm.

For Rollei SL66 40mm, 50mm, 80mm, 150mm, 250mm

For my nature photography, I use Nikon F3s, mainly zoom lenses: 17 mm-35 mm; 28 mm-105 mm; or 70 mm-210 mm, plus extenders.

Film

Black and white: Kodak Tri-X ASA 400 (previously) Super XX

Color: Fuji Sensia ASA 100 (previously) Kodachrome and Ektachrome

Film Developer

Kodak D-76 1:1 68°

115

Enlarger

Durst Laborator S-45 Special (for 35 mm, 2 ¼ × 2 ¼, 4 × 5)

Printing Papers

Proof prints/contacts/publications: Kodak Polycontrast II RCF-glossy

 Ilford Multi-grade IV RC-glossy

Exhibition/archival prints: Kodak PolyMax Fine Art DW fiber base glossy

 Ilford Multi-grade IV FB DW-glossy

Paper Development

Kodak Polymax Type I

Printing

Normal dodging, burning, contrast filtration

No multiple negatives or digital manipulations

Technical Advisors

Marcus Abolofia, Sam Angeloff, Dick Busher, Paul Dorpat, Greg Gilbert, Hans
Jorgensen, Rod Slemmons, and Hugh Stratford

Darkroom Designers and Builders

David Haakensen, Anchor Jensen, Sue Olsen, Robert Randlett, and Peter Randlette

117 / SELF-PORTRAIT, SEPTEMBER 1988

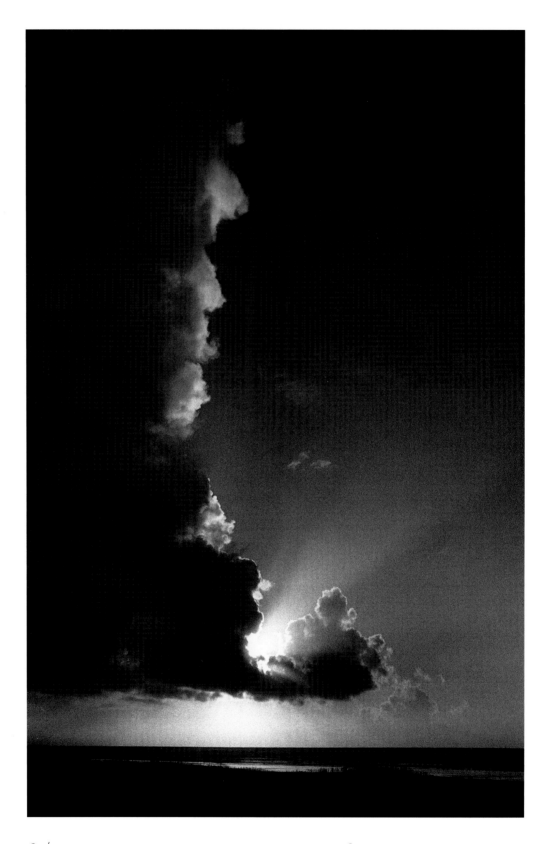

118 / SUNSET AT LONG BEACH, DECEMBER 1987